P...ography
in a week

Philip Thomas

Headway · Hodder & Stoughton

ACKNOWLEDGEMENTS

The author would like to thank John Morrison, Lee Frost and William Cheung for their photographs, David Connor of *Buying Cameras* magazine, Lesley and Jayne at Headway and, most of all, Colleen for her patience and encouragement.

Photographs © Philip Thomas pages 6, 9, 12, 13, 15 (top), 22 (bottom), 24, 25, 26, 28 (top), 29, 30, 31, 33 (both), 35, 37 (both), 39, 41 (both), 43, 44, 48, 50, 51, 52, 53, 54, 55, 56 (bottom), 60, 65 (bottom), 67, 68, 69, 70, 71, 72, 73, 74, 75, 76, 77, 78, 80, 83, 85, 87, 88, 90 (bottom), 91.
Photographs © Lee Frost pages 10, 11, 15 (bottom), 16, 18, 19, 22 (top), 28 (bottom), 32, 38, 40, 47, 49, 56 (top), 57, 62, 64, 65 (top), 66, 81, 84, 90 (top).
Photographs © John Morrison pages 7, 8, 21 (bottom), 45, 58, 59, 61, 63, 82, 89, 92.
Photograph © William Cheung page 21 (top).

British Library Cataloguing in Publication Data
Thomas, Philip
 Photography in a week. – (Sports in a week)
 I. Title II. Series
 778

ISBN 0 340 55783 4

First published 1992

© 1992 P Thomas

Typeset by Rowland Phototypesetting Ltd, Bury St Edmunds, Suffolk. Printed in Hong Kong for the educational publishing division of Hodder and Stoughton Ltd, Mill Road, Dunton Green, Sevenoaks, Kent by Colorcraft Ltd.

CONTENTS

INTRODUCTION

'It is now perfectly easy for anybody of normal intelligence to learn how to take pictures in no more than ten minutes.'

Kodak advertisement, 1890

Hard to believe, but the above advert is proof that there have always been people telling other people that photography is easy. In fact, of course, it is – especially now with the amazing machines available for creating photographs. Or rather, the mechanical side of it is easy – how hard can it be to move the index finger minutely in a downwards direction onto a shutter button? – but there is a lot more to photography than just that.

It is estimated that we take more than 50 billion photographs every year; in Britain alone, there are more than 40 million cameras shooting millions of pictures each week – one of the reasons, no doubt, that Kodak is one of the biggest companies of any type in the world.

We take photography for granted now, whipping out a camera that can focus, expose and wind-on the film without us giving it another thought, and expecting top-notch pictures to come gushing back from the photo lab.

Sadly, of course, of those 50 billion photographs, at least 49 billion – and probably many more – are of no interest to anyone other than the taker and his or her immediate family, and have absolutely no artistic or photographic merit at all. Despite the extraordinary improvements in camera and film technology over the last ten years or so, the inherent quality of most of the world photographs hasn't improved a jot. They may be sharper and better exposed – in fact, they undoubtedly are – but they're just as dull as ever.

The reason is simple – while a camera can help you with the technical side of photography, the only thing that can create a good photograph is the person pressing the shutter. You need an understanding of how photography and light work together to create an image, and you need to know what to do to get an idea that's in your head onto the film. Finally, and most importantly, you need an eye for a picture; for its composition, and for the photograph's decisive moment – in other words, when exactly to shoot, and when to leave the instant uncaptured.

It is these elements that I hope we'll weave together over the coming week of this book. Although compact cameras can be the source of much enjoyment, I have aimed most of this book at the Single Lens Reflex (SLR) user, since these are the cameras that allow you the most flexibility and creativity. Compacts are wonderful point-and-shoot machines, but the difficulty in taking the decisions yourself and making the camera bend to your will make them frustrating to many keen photographers. SLRs can be bought very cheaply, and indeed an inexpensive one will cost you much less than a top-of-the-range compact.

INTRODUCTION

As you'll find, photography's technicalities are surprisingly easy to master, and though there are those who insist an appreciation of light and the possession of a photographic eye is something you're born with, I've found that not to be the case. You can learn photography – we're doing it all the time – and, unlike painting, you don't need a built-in aptitude to start shooting. You just need to learn from your mistakes, and learn how to look – at other people's work as well as your own.

The fact is that there *are* photographic geniuses, just as there are literary and musical geniuses, and if you turn out to be one of them, you'll soon have forgotten about this book and will be making a tidy living from the professional photo circuit. But most of us improve over months and years, as we experiment with the technology and techniques of photography and as we find our own photographic voice within ourselves. At infinitely differing speeds, we develop an eye for a picture, and the joyful knowledge that we've never arrived, that we can always improve – both technically and artistically – is one of photography's greatest pleasures.

There is much mystique attached to photography – it all looks so complicated, and the glamour attached to the professional end of the pursuit doesn't exactly make it any more approachable. But the good news is that photography isn't about physics, chemistry or mathematics. It's about looking at the world, and it's about expressing yourself visually without having to have the skills of a painter. In that sense, it's a gift, and it is, for millions of people around the world, not only an absorbing hobby, but a creative one as well.

So. Are you ready to take some snaps?

BUYING A CAMERA

'To give yourself a head start, you should use the best equipment you can. Jacques Henri Lartique didn't need good equipment to take great photos, but then the Lartiques of this world are very unusual.'

David Bailey

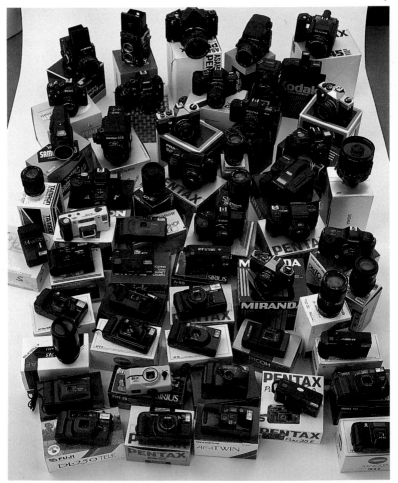

Despite the inimitable David Bailey's refreshing honesty, you'll hear the reverse being said often enough – that equipment doesn't matter, that all you need is a piece of light-sensitive material and a bottle-bottom for a lens, and anyone can go out and take great pictures. In a sense, that's true – some of the greatest photographers of all time only ever used

cameras that now seem breathtakingly basic – Lartique among them. But modern photography offers so many alternatives that the very act of choosing a camera can be enough to put you off the hobby for life.

It's important to know what different camera types are available, what they can do for you, and how they can help you take the pictures you want to take. Armed with that knowledge, camera shops miraculously lose their air of underlying menace.

Negative size

The first decision is exactly how large you want the negative size to be – a vital consideration, since the size of the negative affects, more than any other single factor, the quality of the pictures you'll produce.

The range is phenomenal – from the postage-stamp size of the now more-or-less-defunct 110 and Disc cameras to the professional hardware that takes film a staggering 10×8 inches in area.

Clearly, the ideal is one of the stations in between those two extremes, and that's why the vast majority of photographers, and nearly all amateurs, choose the 35mm format, which is the standard size for the two most popular camera types – the compact and the 35mm Single Lens Reflex (SLR).

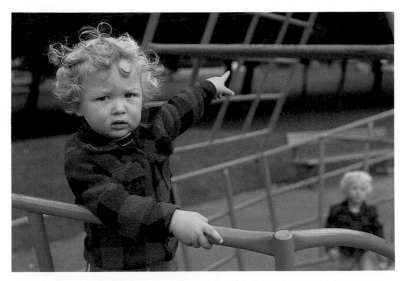

The slightly wide-angle lens that comes with nearly every compact (usually about 35mm) is ideal for many situations, as here when the photographer wanted to get close to his little boy, while including his other son in the background

MONDAY

The Compact

Compacts exploded onto the market in the mid-1980s, changing photography forever. Until then, the only option for the casual snapper was a 110 camera – the long, thin variety that look like a spy's secret picture-taking device. Although they were completely automatic, and handily-sized for the handbag or the top pocket, they had many drawbacks – a tiny negative, unsophisticated focusing mechanisms and *very* inaccurate exposure measurement.

The compact changed all that – for the first time, here was a pocket-sized camera that accepted 35mm film – large enough to produce an acceptable blow-up the size of a road-side advertising hoarding – and with excellent metering and focusing mechanisms.

They are essentially tools for simplifying the photographic process. Either autofocus (the lens actually moves to bring objects into focus) or fixed-focus (the small aperture gives sufficient depth-of-field that most of the shot is acceptably sharp), they negate any worries about focusing, as well as taking metering decisions for you – you're just there to press and shoot.

Compacts are the ultimate late-20th Century invention – you don't have to understand them to make them work, and falling off a log is a major logistical problem compared with picking one up and using it to take a picture. Indeed, so popular have compacts become that some

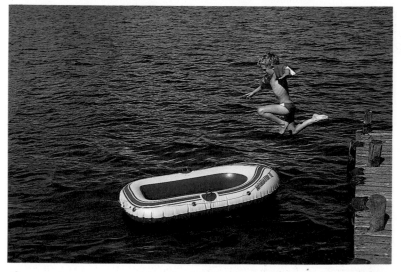

Compact cameras are ideal for fast-moving situations. No focusing, winding-on or exposure readings are necessary, leaving you free to concentrate shooting the pictures

manufacturers, for instance the Japanese giant Olympus, have stopped producing SLRs altogether.

Cameras, though, aren't cars. It's safe to assume that you can spend your life not knowing your gear-shift from your spark plugs, and have many years happy motoring. With photography, though, if you want to go beyond the happy snaps and start creating proper images, you have to learn a thing or two about the processes involved first.

Choosing a compact

Of course, compacts vary in sophistication and specification, as well as in price. There are basic models costing as little as £40, while others with sophisticated metering, a zoom lens, intelligent flash and motorised everything can set you back £250 and more. Whichever you choose, though, there is always one basic problem – they are designed to take the decisions away from the photographer, and they assume you don't know what you're doing. Of course, that's fine while you don't want to be bothered with making decisions, but when you come to the stage where you want to tell the camera what to do, you hit a problem. It won't listen.

The more sophisticated compacts can help a little – they have backlight compensation for shooting into the light, they have pre-flash blips before the main flash fires for the elimination of the dreaded red-eye (the pre-flash causes the eye's iris to close, so the flash's light doesn't bounce off the red-coloured retina, which is the cause of red-eye), they have flashes which will fire exactly the right amount of light into a darkened face without affecting the background. On the negative side, though, you're

stuck with the lens they come with, you can't override the DX-coded film speed to up- or down-rate the film (that is, rate it at a higher or a lower ISO speed than the manufacturer recommends), or indeed often use ultra-fast or ultra-slow film, and you can't use studio lights, long exposures or, in many cases, filters.

The sophisticated zoom-compacts often allow you to zoom from about 35mm to 70mm, the longer end being ideal for a shot like this

Because compacts are built to take problems out of your life, you may find that sometimes they treat you like an idiot. For a shot like this, which mixed daylight and flash, the photographer needed to be in control of his gear, setting the correct shutter speed and aperture for the fill-in flash to do its work – so he used an SLR. Some compacts may just be able to create this effect for you – if they have a 'fill in' flash capability – but the results will be much more hit and miss. See page 29 for an explanation of this technique

So, you can see that the compact is the TV dinner of cameras. Useful, hassle-free, quick and easy, but lacking the sense of achievement, the ups and downs and the sheer joy of cooking something yourself.

For those things, you need to look for an SLR.

The Single Lens Reflex

Film wind-on lever

Shutter speed dial

Pentaprism

Film rewind lever and back opener

Shutter release with screw for cable release

Film ISO dial

Lens release button

Flash socket for flash cable

Self timer

Lens speed (f/1.4)

Lens aperture ring

Lens serial number

Lens length (50mm)

MONDAY

Flattering portraits. Night shots. Sports pictures. Atmospheric landscapes. Special effects . . . These are just some of the photographs that a 35mm SLR can help you create and that a compact will have major problems with. For sheer versatility, the SLR is quite simply the tops.

The SLR has many advantages over the compact. Through its mirror and pentaprism (the bit that sticks up above the eye-piece) arrangement, it allows you to see *exactly* what you're photographing (the mirror snaps up and out of the way at the instant of exposure). You can change lenses, even mid-film, giving you options from 6mm to 2000mm, from wide to telephoto via zooms and every focal length you've ever dreamed of. The range of shutter speeds is often very large – from one second to 1/1000sec at the very least – and the range of apertures can be dictated by you and not the camera, allowing creative use of depth-of-field (for instance when you want to throw a distracting background out of focus). The SLR's exposure measurements are Through The Lens (TTL), and sometimes Off The Film (OTF), allowing a greater accuracy than any compact can offer. And finally, you can use any flash you want (even if the camera has an in-built flash), including studio lights and multi-flash arrangements, allowing you enormous creative potential.

For this shot, the photographer used a hand-held flashgun, mounted on a stand and bounced into an umbrella, to light his model, and for such a relatively simple set up, an SLR is a must. Compacts come with the flash built-in, and the only way to deal with that problem is to take a hacksaw to your camera and force the flash off. Hardly advisable, and unworkable!

Choosing an SLR

SLR cameras fall broadly into two categories – manual or autofocus.

The autofocus SLR is a relatively new innovation – Minolta launched the first viable model in the mid-1980s – but any initial doubts (and there

MONDAY

were many) about a camera's ability to focus as quickly or accurately as a human being have been washed away by an extraordinary tide of technology. Even professionals – and calling those people dinosaurs does the large reptiles a disservice – have embraced autofocus; Nikon's astonishing F4 sells by the truckload to sports, fashion and press photographers who can't believe their eyes when they see how responsive the autofocusing mechanism is.

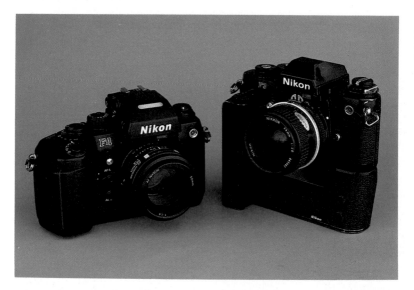

The Nikon F4 (left) – the professional choice, which took over from the F3 several years ago as the Nikon flagship. It costs a small fortune, but there are SLRs to fit most pockets, as well as plenty that are even more expensive than the F4

The F4, however, costs a lot more than many amateurs could and would want to afford. Luckily, there is a huge range of autofocus SLRs available, and many many manual-focus models are still being manufactured.

Whether to go for autofocus or manual is a vital decision. You can use autofocus lenses on a manual mode, allowing you to focus yourself, and for this reason, as well as the increasing sophistication of autofocus cameras, they are starting to take over from the manual models in popularity. Indeed, it is becoming clear that sooner or later – and it will probably not be for another 10 or 15 years – manufacturers will stop producing manual lenses, and manual cameras will be phased out.

Autofocus cameras are, however, generally more expensive than manual models and you do have a wider range of independent lenses (those made by a manufacturer other than the camera's maker, like Sygma,

Tamron and Tokina). The decision has to be carefully balanced, but if most of the time you're happy for the camera to take over the trouble of focusing (and for some, like the old or disabled, this is a positive boon), then autofocus is for you.

These days, SLRs offer a large range of options when it comes to measuring exposure. **Manual** reading means that the camera simply measures the light level and you decide on the aperture/shutter speed combination. **Shutter-speed priority automatic** gives you freedom to choose any shutter speed you like, and the camera will work out the aperture for you. This is particularly handy when you're shooting fast action or using heavy lenses, as you can dictate a faster shutter speed than usual. **Aperture-priority automatic** will do the reverse – you choose

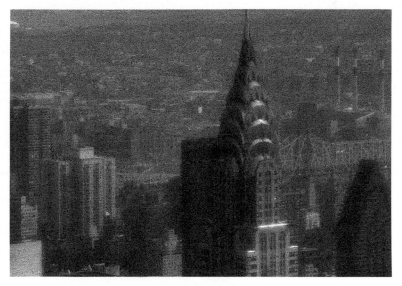

Experimenting with films is one of photography's great pleasures – uprating them, downrating them, generally mucking about with them. Sadly, many compact cameras are DX coded, something which cannot be overridden, and many will not accept ultra-fast films, like the ISO1000 I used here, leaving you rather stuck if you fancy a try at something different

the aperture, the camera sets the shutter speed. This is ideal when you want to have control over the depth-of-field, choosing a small aperture for instance when you want a lot of the shot to be sharp. Be aware, though, that a very slow shutter speed to compensate for a small aperture may result in camera shake. Finally, **Program** mode does everything – simply point, focus and shoot and the camera will work out the exact exposure for you.

MONDAY

Bits and pieces

What else should you look for when buying your camera? Again, it depends on how much control you want, and how much you're going to let the camera take the strain. Before we talk about a few little bits that come in handy, though, it's worth remembering that when you buy a camera to take you into serious photography, you're not just buying a body, you're buying the entire system – so it's a good idea to have a look at the lenses and accessories that are either made by the manufacturer or are compatible with their products. Should you fall in love with ultra-wide angle shots, for instance, it can be troubling to find out that there are no suitable lenses for your body.

Viewfinder information is important if you intend to shoot using the manual exposure mode a lot. (For a discussion on exposure modes, see Sunday's talk on Exposure.) There's nothing as irritating as having to constantly take your eye away from the viewfinder to look on the camera body to see what shutter speed and aperture you're using – it wastes time and soon wears you down. If all the information is in the viewfinder, that's a big help.

Built-in motordrives are becoming more and more common, and while these add necessary weight, they save you having to buy a bolt-on winder and come in mighty handy. Having a winder allows you to concentrate on the shot, and after you've used one for a while you'll appreciate how stopping to wind on can interrupt the flow – particularly if you're shooting portraits or fast-moving subjects, when timing is all important.

How an SLR works-cross section

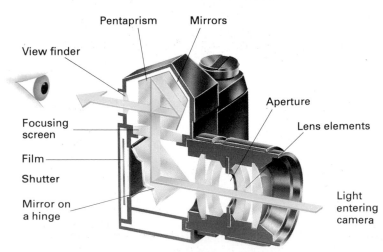

Pentaprism Mirrors

View finder

Aperture

Lens elements

Focusing screen

Film

Shutter

Mirror on a hinge

Light entering camera

The limitations of the compact become crystal clear when you want to inject a little creativity into the proceedings. To add a feeling of movement, you need to use a slowish shutter speed (for this shot, I used 1/15sec), something only an SLR can offer you, since shutter speeds are automatically selected for you by compacts

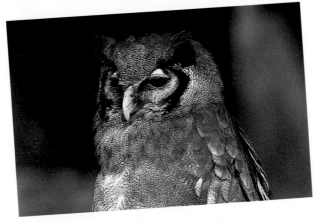

Because compacts have fixed lenses, you may find they don't give you the flexibility you need. Even the most sophisticated zoom-compacts don't have lenses long enough to capture beasts or birds like this – the photographer used a 200mm telephoto lens to shoot this owl

MONDAY

A **depth-of-field preview button** is now a rare thing indeed, but it's also a wonderful little feature. All it does is stop the lens down to the taking aperture so that you can see exactly what will be sharp and what won't, allowing you to minutely adjust the depth-of-field to your requirements. Normally when you're shooting, the lens doesn't stop down until a split second before the moment of exposure, so you always see the scene at the maximum aperture of the lens, giving you the brightest view of the scene possible. A depth-of-field preview button takes the guess-work out of the whole affair.

Of course, there are many other enticements offered by camera manufacturers, like a **built-in flash**, for instance, which is useful when you're shooting happy snaps of parties, but a waste of space if you want any power behind your flash pictures. You should carefully decide which specifications are good for your photography, and choose your camera accordingly.

A final word about the vast difference in the price of cameras. In photography, as in everything else, you get what you pay for, and Nikon, Leica and Hasselblad are simply made with more care and trouble than the cheaper makes, although for most amateurs the likes of Canon,

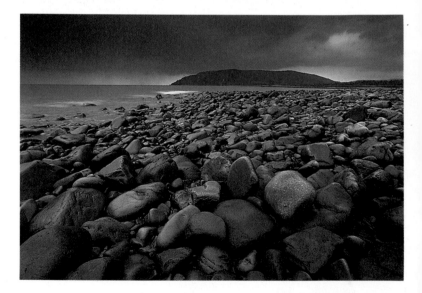

It's the inability to change lenses with compacts that persuades most photographers of the merits of the SLR. This landscape, for instance, was taken on a 21mm lens, far wider than any compact can offer you, and the photographer used a grey graduate filter as well, something that's tricky to say the least with a compact

MONDAY

Pentax, Olympus and the less expensive Nikons will provide many many years of hassle-free picture-taking.

I happen to think David Bailey was right when he said that you *can* drive across the desert in a family saloon. But why give yourself a headache? Get a four-wheel drive, designed for the job, and then you'll *definitely* make it across . . .

Caring for your camera

DO'S

Do store your camera in a **dust-free environment**. If you have a gadget bag, keep it closed. Keep your gear out of the sunlight.

Do use a **skylight or UV filter** on your lenses at all times – not only do they filter out unwanted UV rays that you can't see but the film will, but if you drop your camera a cracked filter is cheaper to replace than a cracked lens.

Do keep the **lens cap** on whenever you're not using the camera.

Do use a **lenshood**, preferably a rubber one, and an eyeshade for the viewfinder. It not only reduces flare but acts as a cushion should you knock your camera.

Do use the **neckstrap** whenever you use your camera, and put it round your neck, not over one arm where it can swing and be damaged.

Do **remove batteries** if you're storing the camera for longer than a couple of months.

Do store your camera with the **shutter un-cocked** (fire off a frame and don't wind on). This removes the tension from the shutter blades.

Do **check the camera's screws** regularly. If necessary, tighten them.

Do check that **everything's working** properly periodically. Open the back and look at the shutter opening, and fire the flash through the back of the camera to check the sync-speed (the shutter speed at which you should synchronise the flash – usually 1/60sec, 1/125sec or 1/250sec, and usually marked on the camera by being highlighted in red or orange).

Do have your camera **serviced** once every five or so years.

DON'TS

Don't get the camera **wet**.

Don't **touch the mirror** inside the camera – it doesn't have the glass protection ordinary mirrors have, and is extremely delicate.

Don't **pour cleaning fluid directly on the lens**. It may run into the mechanism. Put it on a tissue first.

Don't use anything other than a **proper lens tissue** to clean lenses.

Don't use **silica-impregnated tissues**, like those for cleaning spectacles. They build a chemical coating on the lens.

Don't **ignore the dust** on the outside of the camera – it soon becomes dust inside the camera and can dry out the lubricants.

Don't **force anything**.

Don't put your **fingers on the lens elements**, front or back.

Don't worry about the **tiny black specks** you may see in the viewfinder – these are just in the pentaprism and won't affect the pictures, although it's nice to have them professionally cleaned away once in a while.

And remember . . . an unloved camera will seek its revenge at the worst possible time!

SLR cameras offer you almost unlimited creativity and allow you to experiment in all sorts of directions. Close-up and macro work, for instance, can only really be attempted if you have an SLR, since you need special attachments or lenses

TUESDAY

UNDERSTANDING LIGHT

'There's no such thing as bad light. People look at overcast days and say, "What a dull, lifeless day", but that light is beautiful. It's lovely, perfect light if you want it to be.'

Terence Donovan

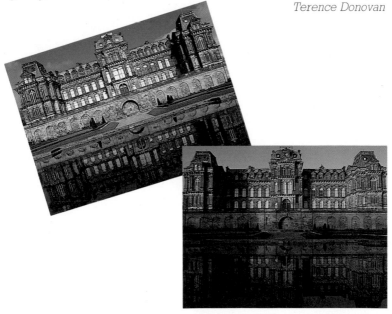

Same subject, same day, completely different photographs. The benefits of understanding that light changes from hour to hour – indeed from minute to minute – cannot be underestimated. Mind you, once you've understood that, you then have to be prepared to wait from 2 p.m. (left) until 5.30 p.m. on a winter's day (right) to capture architecture at its best. As you can see, though, the far more attractive result makes it well worth the wait

Light. A strange choice of subject for just day two of this week? Absolutely not, because after you've decided on exactly how you're going to physically *take* pictures by choosing your camera, the first and most vital lessons to learn are all to do with light.

Light is photography, both in the most literal sense – without it, there would be no photography, or life come to that – and in an aesthetic sense. Because very, very, very rarely is it possible to take consistently good pictures without having an understanding of light: how it works, how it can change your photographs, and how it interacts with the lens, the camera and the film.

TUESDAY

Seeing light

It's both a technical and an artistic thing. Artistic, because as photographers we have to appreciate light – hard light, soft light, warm light, cold light, direct light, indirect light, artificial light, sunlight. And technical, because the light we see is not always the light the film sees.

Our brains perceive all light as much the same – it all more or less looks white. But in reality, light veers from blue to yellow via green, magenta and many other hues. That's why, when you shoot indoors at night and the flash doesn't fire, the household bulb that seems to cast a pure white light around the living room comes out a distinctly orange colour on film. It is a tungsten light, and tungsten light is in reality orange-coloured.

Modern daylight-balanced films (i.e. 99 per cent of the films used) are manufactured to reproduce daylight and flash as normal – Kodak, for instance, uses midday at Rochester, New York, the company's headquarters, as the yardstick for typical daylight, which is absolutely fine if you happen to be shooting in that part of the world at exactly that time.

Of course, most daylight throughout the world falls within acceptable limits of this norm, but if you're shooting in tungsten light (household bulb) or under fluorescent strip lighting, you'll notice that the results look anything but normal – in fact, there will be orange and green colour casts respectively.

This is because light is measured by its colour temperature (in Kelvins) and all light has a different colour temperature. A candle, for instance, has a temperature of approximately 500K, whereas midday in the mountains clocks in daylight that is a staggering 12,000K. Normal daylight is about 5500K.

This is a phenomenon that can be used to your advantage if you are after surreal effects (light a portrait with a fluorescent light and see how surreal it looks!), but it's also something you need to be aware of, and able to combat, if you're not.

Filters

Filters are your ally here – colour compensation filters that are designed to negate any colour cast in the light and bring it back to normal.

For shooting in tungsten light with daylight-balanced film, you need a blue filter – an 80A – which will then allow the film to reproduce the scene as normal. These are available from most photographic outlets, although if you're pre-warned about the situation, you'd be better off using tungsten-balanced film which is manufactured to reproduce tungsten as normal. Alternatively, make sure you have a flash with you, and use that instead.

TUESDAY

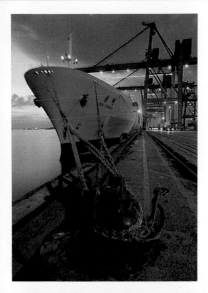

At dusk, you'll find that the melting pot of colours from the various light sources can give bizarre results. Here, the ship in harbour is bathed in fluorescent light from the dock giving an odd green cast, yet the background is a normal dusk-colour. You wouldn't see this, as the brain converts all light to as near white as possible, but film can't do the same, hence the surprising and exciting pictures available

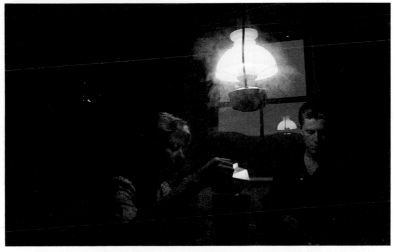

Sometimes when you're shooting indoors, the flash won't fire and you'll be left with an orange-coloured, underexposed image that's fit for the bin. This is because household bulbs – which are tungsten – have a different colour from daylight or flash sources, a colour which our brains revert back to white for convenience. Sometimes, though, you can use the colour casts to your advantage, as here when the atmosphere has been enhanced by simply using a kitchen bulb to light the scene

Night-time can be a time of riotous colours, with sodium, fluorescent, tungsten and halogen lights all conspiring to create a Christmas tree of colour. Some photographers attempt to filter out these strange casts, but really there's no need – you're fighting a losing battle, so go with the flow

For fluorescent light, things are a little more complicated, since it doesn't have a uniform wavelength and is therefore impossible to filter out perfectly. A magenta filter – a CC30M – is as close as you'll get, although there may still be the odd green tinge in there somewhere. Again, negate the need for filters by lighting the scene with flash or switching the lights off if there is enough daylight coming through the windows into the building.

Contrast control

Apart from colour casts, film differs from our brain and eyes in one other important respect: it can't handle the contrast that our eyes cope with every single day.

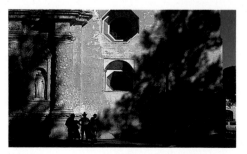

The stark contrast between light and shadow can add an extra element of mystery and interest to a photograph. If there are large areas of darkness, be careful to expose for the lightest areas so the shadows appear deep black, otherwise you may end up with an over-exposed shot with weak shadows and dull highlights

TUESDAY

For proof, try this test. Put an object on a window sill, or ask someone to stand with their back to the sun. No problem there, the detail will be easy to see even if the light behind the subject is very strong, and the colours will be discernible.

Now squint your eyes to a slit. The difference is extraordinary – the detail disappears and the colours merge into a grey/black mess, and this is exactly what the film will see – if you were to take a picture, the results would prove it. The fact is that film technology hasn't been able to catch up with the extraordinary genius of our own biology.

If in doubt about how film will cope with contrast, the squinty-eye test is always worth the couple of seconds it takes. If the detail goes, you know that some kind of remedy is in order – either you need to increase the exposure by a couple of stops (increase the aperture from, say, f/5.6 to f/4, or increase the shutter speed from 1/125sec to 1/60sec), or you need to use a large white, gold or silver reflector to bounce some light back into the shadow areas. After a couple of incidents like this, you'll join every professional on the planet, and have a selection of reflectors in easy reach whenever you're shooting anything. At the very least, you'll know that the object or the sitter will have to be moved so that the light is falling onto them from behind you.

Changing daylight

Of course, the majority of us shoot most of our pictures outdoors, but in our Western culture of cities and offices, we may have lost our awareness of just how varied daylight is. Shooting at dawn, midday and in the late evening will have utterly different results, and this appreciation of the changing quality and colour of light is one of the most important lessons to learn.

Dawn and pre-dawn give the world a very steely grey, blue or sometimes orangey hue, ideal for many a landscape, with the mist rolling off the hills and lakes and the colours beautifully muted. Travel and landscape photographers consider this to be the most productive time to shoot, as the light gives texture and form to the world, and there is a clarity in the air that just isn't present at any other time of day.

As the sun rises in the sky, the light changes dramatically, cooling down (a confusing term, since the colour temperature is rising) to the more normal blue-bias that the film manufacturers make their stock to reproduce accurately. Although the technicalities may be right, however, as the sun rises towards its apex, picture-taking becomes less and less attractive, particularly for landscapes, portraits and architecture.

It's all to do with the shadows – a portrait at midday will produce harsh shadows under the nose and chin, and the white/blue tone of the light is hardly attractive for anybody's face, giving them an unhealthy pasty look. When the light comes from above, buildings have little light on their facades, and the landscape loses all its texture and form.

For these reasons, midday shooting is not something professionals enjoy, and if you do find yourself wanting to shoot the odd portrait when the sun is right over your head, the best thing to do is to find an overhanging tree or archway and shoot in the shade, perhaps using a warm-up filter (the straw-coloured 81A or B is a favourite) to add touch of healthy tan to the subject's visage. If you're shooting landscapes and architecture, the best thing to do is find a bar and have a drink until the sun sinks lower in the sky.

The afternoon and evening invite picture-takers to return to their work, since the light is even warmer and more attractive than at dawn, and is a lovely golden colour. The later in the evening you shoot, the better the light becomes for portraits, since squinting into a powerful sun is no one's idea of fun. As the sun sinks to the horizon, it has much more atmosphere to penetrate, causing the light to weaken and the colours to turn golden-orange. Once again, it's a perfect time of day to shoot everything from people to St Paul's Cathedral.

After the sun has slipped away, the light is still in the sky, and now is not the time to pack up, but to continue taking pictures. In fact, this magical twilight hour or so beyond sundown is exactly when most night time city-scapes are taken – a pitch-black sky is less interesting than the last rays of light in the sky, and you should keep using it until all light has disappeared.

Evening sunlight is ideal for many subjects – warm and soft, and the provider of the odd interesting shadow. It invariably adds to rather than detracts from any picture. This shot taken at midday would have been harshly lit and blue-hued, and although the subject's interest may have saved it, the final result would have been far less attractive

TUESDAY

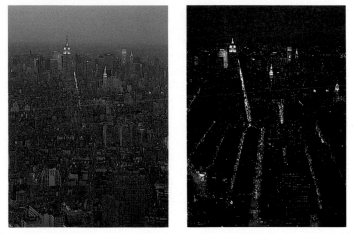

Light can change a scene utterly, as these night shots at New York illustrate. If you shoot with the daylight's glow still in the sky, but with the streets lights just coming on (left), the atmosphere is very different from that if you wait for the light to disappear completely from the sky (right). Personal preference dictates which one you'll choose, but be aware that 'night' doesn't always have to mean pitch black skies, and many professional 'night' shots are in fact taken at dusk

Outdoor people like farmers, golfers and fishermen are presumably joyfully aware of the changing nature of sunlight; for the rest of us, part of the fun of shooting outdoors is experimenting with how daylight changes, and finding our own particular favourite time of day.

The direction of light

The relationship between the camera, the subject and the light source will utterly affect the outcome of your picture. Basically, there are three ways to light a subject when it comes to the direction of the light – side-light, back-light and front-light.

The basic photo manuals tell beginners to always have the sun at their back, making use of **front-lighting**, and there is good reason for this – contrast is minimised, exposure is as easy as it can ever be, and the risk of flare is virtually nil. The down-side, however, is that this front-lighting is, usually, rather boring – an overall wash of light that gets into every crack and crevice, reducing shadows and therefore minimising texture and form. Clearly, if the light is particularly attractive (lovely and soft, say, and warmly yellow to boot) it can be ideal, and can add to the picture immensely. Much of the time, though, it won't really do a great deal for the art and craft of taking pictures.

TUESDAY

Side-light is fascinating light. Contrasty and powerful, the slanting of light across any but the smoothest surface will bring out the texture of the subject, thus creating a three-dimensional feel in a two-dimensional picture. Texture – along with colour and form – is one of the most important considerations in photography, a fact that's all too obvious if you shoot a side-lit portrait of an old man, a side-lit still-life of an orange skin or a side-lit architectural shot of a church. Without the side-lighting, the texture of these subjects is lost, and texture, of course, is very much what they're about.

Contrast can be a problem with side-lighting, particularly if it's harsh. Always apply the squint test to see if the unlit half of the subject reduces to a featureless mass, and take steps to remedy it. This usually means using some kind of a reflector to bounce some light back into the shadows, although with subject as huge as a church, it may mean waiting an hour or two for the sun to move round a touch – unless you can get hold of a sheet of white card a hundred feet high.

Back-lighting is something else again. The starkness of a silhouette is easy to create – just shoot into the sun and let the camera's meter take care of everything for you. Beware of flare, however, by making sure the sun is just out of shot, or right behind the subject, and always, always use a lenshood, which is one of photography's most underrated and under-used little accessories.

As long as you have a relatively bright light-source behind your subjects, any camera meter should automatically create a silhouette, although if you did want a little bit of detail, then increase the exposure by a stop or so (change from f/11 to f/8, or from 1/250sec to 1/125sec). Watch for flare in your lens if you're shooting into the light

TUESDAY

If you want detail in the subject, for instance, when you're shooting a portrait and want the golden halo of light around the hair but also want to see what the person looks like – then extra care is needed. Yet again, a white, gold or silver reflector (you can use a piece of card, or buy them ready-made) comes into its own, or you may wish to fire a little fill-in flash in there (see panel for an explanation of this technique).

The trick with back-lighting is to be aware of how it will affect your subject – and act accordingly. If you're after a simple black shape of something recognisable like the Eiffel Tower or a tennis player serving at full stretch, fine. If you want detail in your subject, then don't expect the film to be able to cope.

Harsh light, soft light

Photographically, of course, we shouldn't just be concerned with light, we should also be considering the shadows it creates. Shadows can aid composition, help to isolate your subject, add texture, and change the mood of a picture, and it is this relationship between light and shade that is the very essence of photography.

Harsh light – produced by a light source that is either very strong or very small or both – produces shadows, and the smallest, brightest light source you can hope for is sitting up there in a cloudless sky – the sun.

You can use shadows as the very subject of your picture – the shapes the shadow of a building makes, the shadow of a person, the slatted light and dark of the shadow created by a Venetian blind. Or you can use it to force attention on the subject – for instance in a portrait of a person standing in front of a courtyard in shade that reduces to black behind them.

Soft light, though, produces few shadows and is a most flattering light for portraiture – just like the great fashion photographer Terence Donovan says at the beginning of this chapter, when he talks about the typically British overcast days we endure much of the time, and which many photographers inexplicably dismiss as horribly boring, and about as useful to photography as a rubber ladder is to roofing.

Should you be shooting indoors with either flash or daylight, you can soften it easily enough by simply taping some tracing paper over a window or putting a diffusing material over your lights – remember that the further away the light source is from the material, the softer the light will be.

Alternatively, you can soften light by bouncing it around as much as possible – even in harsh sunlight, a white-washed courtyard will reflect so much light around that the effect will be surprisingly soft. White clothing will bounce the light around, softening shadows, and of course the trusty reflector is your best ally in diminishing the shadows.

TUESDAY

High-key and low-key portraits are effective at portraying different moods. The open airiness of high-key (left) is ideal for a feminine portrait, making us feel relaxed and at ease, while the sombre effect of low-key (right) is almost sinister. For high-key, use lots of white reflectors to bounce the light around, and maybe a soft-focus filter to diffuse the image, as well as white clothes and props. For low key, use a black background, take a meter reading off the highlights to ensure the shadows go to black, and use black cloths around the set to ensure that no light is reflected where you don't want it (right)

By mixing daylight and flash you can fill in shadows (see page 29), but by slowing your shutter speed right down you can add dynamism to the shot, too. The flash freezes the features slightly, but the long shutter speed (1/15sec here) adds a movement so the shot is blurred and sharp at the same time. Practise this technique – different speeds combined with different flash strengths and apertures give wildly differing results.

TUESDAY

However you use light, though, the important thing is to be aware of it. If you make a train journey, spend time gazing out of the window and notice how the light falls on the trees. Make a point of looking out of your bedroom window every day to see how the time of day and the time of year utterly affects the light, which in turn affects the atmosphere of the view you can see. Super light is not always there just waiting for us, but with a little knowledge and the ability to really see it, we can make the most of what we've got.

And do remember, there very, very few pictures – a news picture, perhaps, or a picture of your baby's first steps – that can rise above being badly lit . . .

Flash point

There's no need to be afraid of fill-in flash – it's really quite easy.

The vital point to grasp is that your shutter speeds affect the daylight in the background, your apertures affect the flash. First, set your shutter speed to the flash synchronisation speed – usually 1/60sec, 1/125sec or 1/250sec, and marked on your camera by being set in red or orange. Then take the daylight reading, and set the appropriate aperture for that shutter speed.

Then set the flash to fire a quarter as powerfully than it would normally, either by setting the film speed on the flash gun two stops faster (ISO400, say, instead of ISO125) or by simply telling the flash your subject needs a different setting by setting the f/number two stops slower (f/16 instead of the f/8 you may be using). See page 95 for more information on film

speeds, page 85 for information on stops and page 94 for information on f/numbers.

To increase the power of the flash, open your aperture (remembering to adjust the shutter speed accordingly), to decrease it close your aperture. To make the background go darker, increase the shutter speed to, say, 1/15sec.

Experimentation is really the key – shoot lots of frames at different apertures and shutter speeds (though not faster than your flash synchronisation speed), and you'll find many of the shots will look great in their own way.

As with everything in life, light does not exist on its own – its natural opposite is shadow, and you should never ignore the possibilities when it comes to photography. Shadows can add to your compositions, as here when the shot itself is nothing particularly special, but the late afternoon sunlight has added the deep, lustrous shadows, which in turn add their own dimension to the picture. A polarising filter helped to increase the contrast and colour saturation

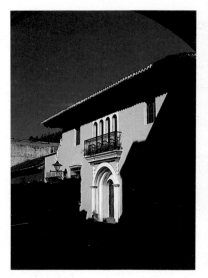

WEDNESDAY

LENSES AND ACCESSORIES

'You should be careful of using too many lenses and accessories. The more you have, the more decisions you have to make. The more decisions you have to make, the less time there is to take photographs.'

Don McCullin

Although you can make a splash with some world-beating pictures with just a camera, a standard lens and a little talent, the fact is that understanding about the lenses and accessories – the back-up system – which lie behind every camera purchase is important to everyone's photographic development. Don McCullin is right about too much equipment bogging you down, mentally as well as physically, but in order to be able to produce on film the pictures you can see in your head, you need one or two extra bits of kit.

Lenses

Wide-angles can be used to great effect for powerful compositions, as here where the extraordinary depth-of-field and weird perspective allows an unusual view of New York harbour

The important news about lenses

Before we talk about the relative merits of wide-angles, telephotos and zoom lenses – and these choices need to be addressed when you're shopping for a lens – let's get the most important thing out of the way first. When it comes to choosing lenses, never underestimate the importance of speed.

Lens speed is nothing to do with film speed, which describes the sensitivity of the emulsion to light; it is, rather, to do with the lens's maximum aperture.

WEDNESDAY

It may well be early morning, but you still need to help your photography along sometimes, as here when a blue filter was used to add a cold cast to the scene and subdue the colours. Note the foreshortening effect – the flattening of perspective – obtained with the use of an 85mm short telephoto

All lenses are described by their focal length and their maximum aperture. Describing an 85mm as just that merely tells you half the story – what we also need to know is exactly how wide the maximum aperture is, because that will dictate the amount of light we can get onto the film. There's another point: an 85mm f/1.2 could well cost four times as much as an 85mm f/4.

The f/number is simply a short-hand way of describing the size of the hole in the lens through which light comes. Most lenses have variable apertures – so that you can regulate the amount of light – and it's the f/number that will tell you the size of the hole. Rather upsettingly, these f/numbers are not only fiddly (f/1.2, f/5.6), they are also upside-down, so that the biggest hole (say f/1.2) has the smallest number, and vice-versa.

When choosing a lens, though, the f/number that's important is the widest one – the smallest one, in other words. Some lenses, especially zooms, are very slow, with maximum apertures of perhaps just f/5.6, and choosing these optics can land you in trouble later. For an illustration, imagine you're shooting a portrait indoors, on an overcast day.

In front of you are two lenses, one a 28–200mm zoom, with a maximum aperture of, say, f/5.6; the other an 85mm f/1.2. The difference in their maximum aperture is a staggering four stops. Since each aperture change allows exactly twice as much light onto the film, that means that the 85mm can let in 16 times as much light as the zoom.

And this affects your shutter speed. If, with the 85mm, you can squeeze 1/60sec out of the situation, the four-stops-slower zoom will force you into

using a shutter speed of 1/8sec – far too slow for a spontaneous portrait. (The figures run like this: 1/60sec at f/1.2; 1/30sec at f/2; 1/15sec at f/4; and 1/8sec at f/5.6.)

The only other option is to use a faster film, and unfortunately faster films tend to mean inferior quality. To bring the shutter speed back up to 1/60, you'd have to replace your beautiful quality ISO50 stock with ISO400 film – which will be far grainier and less sharp.

I've harped on about the speed issue for a long time because it really is an often glossed-over, yet vitally important, aspect of choosing a lens. The slower lenses can be quite extraordinarily cheap compared with their faster cousins, but the difference that just a couple of stops makes will astonish you. Once you've used fast lenses, you'll wonder how you ever did without them.

Focal length

The other important decision you'll have to make when you're choosing an extra lens is the focal length. Lens lengths split broadly into three categories – wide angles (shorter than the 50mm standard on a 35mm camera), telephoto (longer than about 85mm) and zooms, which have variable lengths. Which one is right for you?

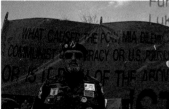

The benefits of a zoom lens are easy to see – from the same position, you can shoot with the wide-angle end (in this case, 35mm, left) and simply twiddle the knob to shoot a close-up with the 105mm end of the lens (right)

WEDNESDAY

Zooms would appear to be the obvious choice – after all, you can infinitely adjust the focal length (113mm, anyone?), saving you lugging lots of lenses around and giving you plenty of creative options. All this is true, but zooms, unfortunately, have a number of drawbacks.

The first is their speed – they are slow compared with fixed-length (or prime) lenses, which could cause you problems, as we've already discussed. The second is their weight; although this is changing as technology proceeds apace, they can be heavy, causing camera shake and cricked necks.

Finally, because they are optically very complex, their quality is not up to the same standard as prime lenses. Again, this is improving as time goes on, and one can't generalise (their are zooms, like the French Angenieux range, that outshine most fixed lenses with room to spare), but when you're after true, biting quality, zooms are not usually the place to look.

That said, you can cover your options with just a couple of lenses if you choose zooms – a 28–70mm and an 80–200mm will see you through most situations – and there's no doubting they are convenient. It comes down, finally, to personal preference. My own? I have three zoom lenses, all of which sit in a camera bag and haven't been used for years. My problem with them isn't the quality or the weight, but the speed.

While the zoom *can* help you when it comes to composition, Don McCullin's comment rings especially true here. If you simply have an 85mm lens, you have to use your legs and your imagination to create a great composition. With a zoom, you have so many options, by the time you've made a decision, the moment could be gone.

The final drawback of the zoom is that it doesn't focus very close. Although some have a 'macro' facility for close focusing, for the average zoom-user, going in close can be a major problem.

Wide-angles usually come a poor second to telephotos in the lust stakes when photographers are thinking about buying some extra lenses. After a short time, however, you'll probably find that the allure of the telephoto starts to wear off, and you find yourself looking more and more towards your wide-angle to add drama and impact to your pictures.

Strictly, wide-angles are lenses with a focal length shorter than the diagonal of the film format – for 35mm cameras, that means anything wider than the 50mm standard.

At one time, 35mm lenses were considered pretty wide; now most compact cameras come with lenses that length and wider, and indeed some photographers use a 35mm as their standard lens. These days, a 28 or 24mm is considered wide, while 16 to 20mm is regarded as ultra-wide, with the fish-eyes (so named because of the way they look, not after the pictures they produce) starting at a mere 6mm.

WEDNESDAY

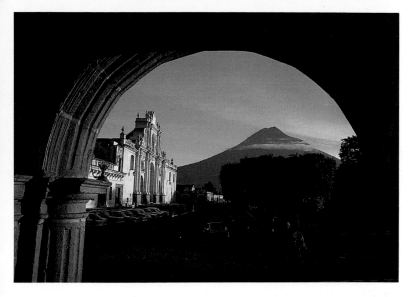

Wide-angles, of course, can simply help you get more in – after all, that's what they were invented for. Here, I used a 28mm wide-angle to include both the church and the volcano in the background, and have used the archway as a compositional device, creating a frame within the frame

The main use for the wide-angle is, of course, to simply 'get more in'. By halving the focal length, you double your angle of view; the area the viewfinder covers is twice as high and twice as wide, so four times the area is covered. Simply by switching from a 50mm to a 24mm, then, can make an enormous difference when you're pushed for space.

There is more to the wide-angle, however, than just this. Its strange distortion will add impact and dynamism to any shot – if you hold the camera back perfectly upright, the distortion is minimal, but tilt it slightly and – bam! – buildings plummet backwards, lines rush to a vanishing point in the distance, and everything is changed.

Another accentuated feature is the phenomenal depth-of-field that wide-angles appear to give. (Appear, because in fact the only things affecting true depth-of-field are the size of the aperture and the distance from the lens to the subject.) The apparently enormous depth-of-field affects the image greatly, though – with a 17mm lens, for instance, everything from about six inches from the lens to infinity will appear to be sharp with an aperture as wide as f/8.

This ability to make the picture absolutely sharp enables you merely to set the focusing once during a session, and forget about it while you sna

away. It can also mean that you can shoot from the hip, an ideal situation when you're shooting candids, for instance in a busy market, where you don't want to be identified as a photographer.

You never get something for nothing with photography, though. Composition, for instance, becomes more important than ever when you use a wide-angle, with so much included in every shot you take. You need to fill the frame with foreground interest and make sure that there are no large areas of uninteresting featureless mass threatening to make the shot dull and undynamic. Try lying down on the ground, or make sure that there's an overhanging branch in the shot to fill up the foreground. That lens sees a lot.

You need to be wary of your metering too, for the same reason. With such a wide angle-of-view, your camera's meter has all sorts of instructions to deal with and it won't know which to take. As you frame your village scene, for instance, the brightness of the sky is saying close the aperture or increase the shutter speed, while the villager's leathery face is saying open up the aperture or increase the shutter speed, and the meter will land you somewhere in the middle.

You could invest in a hand-held meter, or alternatively if your camera has spot-metering (where just a section of scene can be metered for), you could switch to that. Another ploy is to slip on a tele or zoom and, if it's the villager you're interested in, take a reading from his face, change back to the wide-angle without changing the meter reading, and snap away from there. As ever, a little bracketing either side of the meter reading doesn't come amiss. (See Sunday's Exposure discussion for more details.)

Wide-angles are not the lenses for you if you need to use differential focusing to throw the background out of focus should it detract from the subject. They're somewhat indiscriminate in most respects, and care is needed when using them.

For a more selective approach, you should be looking towards the telephoto.

Using teles

Telephotos are hefty, they're often slow, and it's inadvisable to use them without a tripod. But for sports, wildlife, many a portrait and lots of other subjects, telephotos are where it's at.

A telephoto, strictly, is any lens which is physically shorter than its focal length – such as a 1000mm that's actually only about 300mm long. It is made possible by the complex optical arrangement that bends the light back on itself, but in fact the term telephoto has come to mean more or less any lens longer than the standard 50mm.

The cropping out of unwanted details is the great strength of the telephoto – here, a 200mm was used – although the depth-of-field can mean that only a small section of the shot is actually sharp. With a shot like this, that can be a positive bonus, but it's something to be wary of if the whole shot needs to be in focus

Longish telephotos have the attraction of being able to accentuate scale and flatten perspective, so that elements within the frame can be more closely associated with each other. Here, a 200mm lens was used from across the square in Moscow to cut out any extraneous detail and concentrate attention on the soldier and the enormous wall-painting behind him

Just as wide-angles accentuate perspective (big noses, tiny ears, in a portrait), so telephotos flatten it – something best illustrated by, say, a picture of a cricket match taken from behind the stumps; the bowler looks like he's nearly on top of the batsman, not the 22 yards he really is.

37

WEDNESDAY

This flattening of perspective can be an advantage, since flattened perspective flatters faces. In fact, short teles have become known as portrait lenses (see Thursday's Pictures of People) simply because of their suitability for shooting portraits. As the teles increase in length, they come into their own as sports and wildlife optics. As they lengthen, though, so the problems – as well as the planes of perspective – start to bunch up, one on top of the other.

Teles tend to be heavy, so hand-holding them becomes less and less advisable. A general rule of thumb is never to hand-hold a lens at speeds slower than the reciprocal of their length – so, with a 250mm lens, don't hand-hold it any slower than 1/250sec; with a 135mm lens, give anything slower than 1/125sec a miss. An even better rule of thumb is never to hand-hold any tele longer than 135mm. A tripod will soon earn its keep as it ensures pin-sharp results every time.

Focusing is more critical with teles, too. If you're using manual-focus lenses, you need to give extra attention to ensuring your subject is sharp – check and check again before you shoot. With the combination of a lack of depth-of-field and the possibility of camera shake, sharpness will be your major foe in the battle for great telephoto pictures.

There are two types of telephoto, the refractor and the mirror. The refractive tele is a conventional optic, using glass lenses to bend the light back and forth and create the telephoto. Mirror lenses, unsurprisingly, use mirror to do the job, and are lighter and cheaper than their refractive counterparts. They are also usually stuck with one aperture setting, and give these strange doughnut-shaped out-of-focus highlights

WEDNESDAY

Filters

Using filters

The use of filters can add drama and excitement to any scene. Here, I used a combination of a grey graduated filter to darken down the sky and an 81A filter to add warmth and a yellowy tinge to these ruins in Mexico

If you have a glance at the Cokin brochure extolling the virtues of their filter range, you'd be forgiven for being somewhat perplexed. So many choice, so many effects – can they all help your photography to improve?

Well, yes and no. Special effects filters – starbursts, split-fields, prisms and multi-exposure filters to name a few – can add impact to your work, but as a general rule, all filters like these can really do is add a sheen to the image. What they can certainly *not* do is create a great picture from something that just isn't happening in the first place.

Experiment with these filters, by all means, and enjoy them. For the purpose of this book, though, I'm going to talk only about those filters that I think you really do need in your gadget bag – filters that can help you get your vision onto the film, or can help you create in a picture what you actually saw with your eyes. There are only four of them: the soft-focus filter, the polarising filter, the warm-up and the graduate.

The **soft-focus** is a strange old thing. Since photography began, technicians have been trying to make their lenses sharper and sharper, resulting in a situation where sometimes they are just too sharp, and you need to soften the biting clarity a touch.

WEDNESDAY

The soft-focus filter serves that purpose. Whether it's to smooth out the wrinkles in an elderly face or to add mystery and atmosphere to a landscape, a soft-focus filter will do the job. They come in different strengths, and although you can mock one up by using cellophane or even breathing on the lens, it's much better to buy one, so you know what the result will be and you can predict the outcome.

The softness of the final picture is determined by the aperture you use: the wider the aperture, the softer the result. And you'll find that the best results come when you have an area of shadow for the highlights to bleed into – a girl in a white dress against a black background is a good example. Back-lit or side-lit subjects give much more of a pronounced effect than evenly-lit or front-lit ones.

Incidentally, soft focus doesn't mean the same thing as out of focus. The picture is sharp, but the result is, well, soft – so double check your focusing.

Few combinations work as beautifully as ultra-fast film and a soft-focus filter. The film – in this case ISO1000 – subdues colours creating a monochrome effect, and the soft-focus filter adds mystery and delicacy to the scene. Bear in mind that soft focus does not mean out-of-focus – you need to focus as carefully as ever, and keep your filters and lenses clean too

WEDNESDAY

The **polariser** is among the most popular of filters. Invented accidentally by Edwin Land, the creator of Polaroid film, they effectively cut out non-image-forming light, which is basically all the light that is not contributing to the photograph itself.

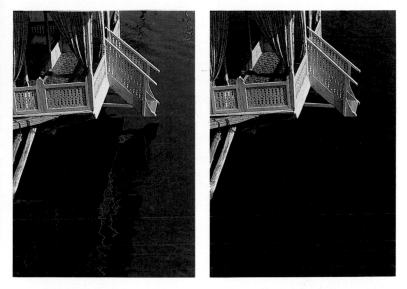

A polarising filter is a vital bit of kit for any photographer, as it reduces reflections and adds punchy colours to the scene. Without a filter, the reflections are there (left), fit a polariser and they're gone (right)

They're primarily used for deepening the blue of a sky, adding depth to colours and cutting out reflections from everything except metal, and are easy to use as long as you know how they work at their best.

Fix one to the lens, and twiddle it to get a visual idea of how it changes the scene – you'll see as you twiddle that the sky darkens, then lightens, then darkens again as you rotate the filter. Sometimes, though, little seems to happen, and that's due to the angle at which you're shooting.

The same is true if you are, for instance, shooting into a shop window and are using the filter to cut out the reflection so you can see the merchandise inside. If you stand head-on to the window, you'll find that the filter has little effect, but stand at an angle of about 30 degrees to the window, and it'll work to maximum effect. The same is true of the blue in the sky – shoot with the sun in front or behind you, and what happens? Nothing. Stand with the sun to your left or right, and the polariser really comes into its own. For colour photography, the polariser is a great friend.

The **warm-up** is a simple-to-use little filter. Like the soft-focus filters, they come in different strengths from straw to deep yellow, and they'll add a lustrous sun tan to your models and an attractive glow to a landscape. The 81 series starts at the delicate 81A and you should have at least that and an 81B in your gadget bag – use them as often as you like. It's hard to overdo it because light is often so unattractively blue.

Finally, we have the **graduated** filter, whether coloured or a neutral grey (see Friday's lesson on landscapes for more of a chat on these wonderful bits of kit). They'll colour the sky or merely knock down the contrast, but using them takes a little more effort than you might think.

The first problem is exposure – always take your reading before you attach the filter, or you'll find that the foreground will burn out and be too light. And don't just make do with any old aperture setting – like the soft-focus filter, the graduate is affected by the f/stop you choose.

The smaller the aperture (f/16, say), the more distinct the division between the colourless bottom and the shaded top of the shot will be. Choose an aperture of say f/2, and the graduation will be much more gradual – to the point where you can't really see where it starts.

Other accessories

Apart from filters, what else should the well-prepared photographer have in the gadget bag? Obviously it's largely down to personal taste, but when it comes to improving your photography, there are a few that I think are vital.

A **tripod** will improve your pictures immeasurably, not only by making sure they're pin-sharp but by slowing you down, never a bad thing. The extra time can help you really think about the composition, and you can get the tripod much lower and higher than perhaps you'd be happy to bend or stretch.

Lenshoods are the cheapest way to immediately improve your photography. Their usefulness simply cannot be overestimated, as they reduce flare and so deepen colours and add clarity.

Flash guns are also vital, even if you have one built in to your camera. They'll not only allow you to shoot when it's too dark for normal photography, you can use them when mixed with daylight to add movement to your shots or simply as fill-in (see Tuesday's chapter on Light). With a camera bag, a cable release for shooting with the tripod, and a small cleaning kit with soft cloths, you're set to shoot more or less anything that comes your way.

Don McCullin is right – don't overdo it on the accessory front, but likewise don't restrict yourself with too purist an approach . . .

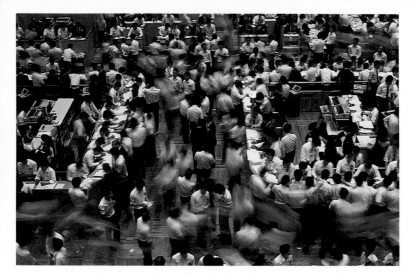

Always take a tripod with you – advice often heard, but rarely acted upon. Not only do they ensure pin-sharp results, but they can, as here, be used to creative effect. I simply used a small table-top tripod, only about eight inches high, placed it on a wall, set the shutter speed to one second and let the busy bees on the floor of the Tokyo Stock Exchange do the rest

UV or Skylight?

Each lens in your possession should be the proud owner of a protective filter at all times. The logic is simple: a scratched filter will cost you a few pounds, a scratched lens a few hundred. The choice isn't whether to use a protective filter, it's which one will you use: a UV (Ultra violet) or a skylight? Many people mix these two filters up, thinking that they perform the same task. They don't.

A **UV filter** removes Ultra Violet light which is invisible to the human eye but which can produce a bluey, hazy effect on film, especially on coasts or in the mountains. It therefore helps, rather like the polariser, to give your pictures more contrast and sparkle.

A **skylight** actually warms up the image, taking out the blue cast that affects many a midday picture, and unlike the clear UV, is rose-tinted. They both perform well, but they are most certainly not interchangeable. Personally, I prefer the colourless UV because sometimes one just doesn't need the rose-tinted hue of the skylight.

WEDNESDAY

Teleconverters

You can virtually double the range of your lenses by spending a few pounds on a good quality **teleconverter** – also called a matched multiplier or doubler.

These simple optical arrangements are basically supplementary lenses which you fit between the lens and the camera body. They come in different strengths, but a 2× converter will instantly transmogrify your 50mm standard into a 100mm tele.

There are, however, drawbacks. The quality is affected, and so you should buy the best converter you can afford, and then use it only at the optimum aperture – a mid-range f/number of about f/11. And teleconverters swallow light – a 2× will reduce the maximum aperture of your original lens by two stops, making a 50mm f/2 in effect a 50mm f/4.

Although they could never replace a prime lens, teleconverters are handy to have as an option should you desperately need that extra power in your lenses.

An 85mm short tele is absolutely ideal for portraits, enabling you not only to fill the frame with a face but also to maintain a respectful distance between yourself and your subject. To shoot this on, say, a 50mm standard lens would have meant me shoving the camera right into the old man's face – uncomfortable for both of us

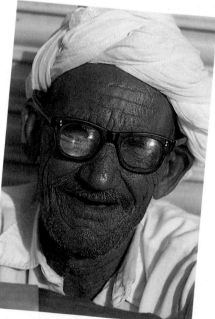

THURSDAY

PICTURES OF PEOPLE

'When you're photographing someone, the photographer is totally unimportant. The sitter is all-important. All you're there to do is record something typical about that person.'

Lord Snowdon

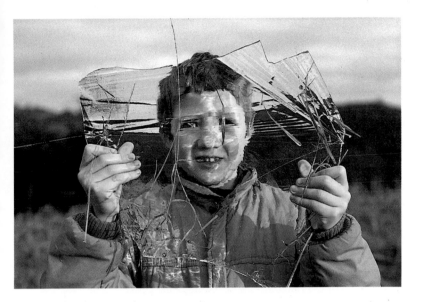

There are always props around that you can use to liven up your portraits – this large piece of ice distorts the boy's features, giving the shot an extra dimension

Stand at the end of any photo lab's production line – the sort that sit in photo processor's windows – and you'll see thousands of prints churning out every minute. There'll be landscapes there, sports pictures too, and many shots of buildings and beaches. But the vast, vast majority of the photographs will have something very simple in common. They will be pictures of people.

Vain as we all are, we all love pictures of people. We love taking them, we love looking at them – just listen to the difference in the reaction to your fascinating holiday slide show as soon as you pop in a shot of a cute little child among all the views and cityscapes; suddenly, everybody's interested again, and no doubt they'll be muttering 'Aaah' under their breath.

THURSDAY

People who need people

Sadly, however, many people pictures aren't as good as they could be. As photographers, we feel intimidated sometimes because our model doesn't actually like having his or her picture taken – not many people do. So, keen to get the pain over with, we rush it. Other times, our victim may be very busy. So we rush it. Or, just as likely, our relationship with the subject clouds our photographic judgement (how can you see your best friend, or your spouse, or your son, with an impartial eye?). So again, thinking we've naturally caught their character, we rush it.

But it doesn't have to be that way. And since we spend so much time shooting pictures of people, it's important that we get it right. A little time spent here, a little thought there – that's what's needed.

Follow just a few ground-rules, and you'll see your pictures of fellow humans improve dramatically.

Thinking through

People photography – whether formal portraiture or a snap at a wedding – is a lot more tricky than it seems. It's not just a question of sticking someone vaguely in front of the camera and firing away. All the photographic elements need to come into play – lighting, composition, timing – as well as an extra element: the capturing of the sitter's personality.

No one, not even the greatest portrait photographers, can continue the pretence that you can capture a stranger's personality on film after a half-hour sitting. Politicians and celebrities have just a few minutes to devote to a photographer, and all that can be hoped for is a brief flash of their true selves – *if* the photographer is both talented and lucky.

But members of your own family? Friends and relations? In these cases, there's no problem – you can shoot them so that anyone who knows them will want a copy of the photo to keep, because it sums that person up so beautifully.

How to move towards that kind of success? Fear not. We're about to find out . . .

The eyes have it

In photography, there are rules aplenty: do this, don't do that, and never even dream about the other. Most of them, it's true, can be safely learnt (and it *is* important to learn them), and then immediately forgotten as you adapt them to find your own way of working.

There's one rule, however, that only a handful of people in 150 years of photographic history have successfully broken, and that rule is

THURSDAY

Warm light, combined with a nice highlight in the eye, is the essence of lighting a portrait. The warmth of the yellow evening light coming in through a window gives the skin an attractive tone, the highlight in the eyes gives them life. It would be hard to light a portrait more sympathetically than this

this: in portraiture, the eyes are the most important element. They must be sharp, and they must be alive.

The sharp eye rule is easily explained. Talk to someone, and what do you do? You look them in the eye – especially when you're listening. You don't look at their mouth, or ear, or nose – you look at those veritable windows to the soul, the peepers.

Add this to the fact that we hate trying to look at things that are out of focus (our eyes are so good at focusing that nothing we look at is unsharp, which is why unfocused pictures are so upsetting), and you have a simple situation. Take a portrait in which the eyes – the important bit everybody will look at – are unsharp, and you have a very irritating portrait indeed.

It doesn't matter what else is blurred (the nose, the ears, the background, the foreground, you name it), the one bit of the shot that should undoubtedly be a sharp as a pin are the eyes.

THURSDAY

Light in the eyes

But that's not all the eyes should be; they should also be alive, full of vigour, sparkling – and you make eyes alive by using a highlight, or, more properly, a catchlight.

A twinkly eye comes from within – you either have one or you don't, and no photographer on earth has ever created a twinkle from nowhere. But an eye without a highlight in it – without a light, whether it be the sun or a flash, reflecting in it – is not so much untwinkly, it's downright dead.

If you're shooting outdoors, you may find a reflector a major help: many professionals would never venture out of doors without an armoury of these vital bits of kit.

They can be simple home-made sheets of card – white, or covered in silver or gold foil – or you can buy them ready-made (Lastolite make some of the best, but there are many to choose from). Either way, you'll be able to position them so they pick up the sun, wherever it is, and bounce it back into the face and – most important, of course – the eyes. (The alternative is to use the sun itself as the catchlight, but as any one who's looked directly into the sun will tell you, that makes you squint, gives you crow's feet and is not conducive to great portraits. Position the sitter with the sun behind them, and use a reflector to bounce the light back in.)

Using a medium-length telephoto, in this case an 85mm, has the bonus of being able to throw a background way out of focus, reducing the clashing of elements and concentrating attention on the face

Backlighting can be lovely – it creates a pleasing halo of light around the hair that gives it an attractive sheen. The problem is that the face, in shadow, may well reproduce too dark, so to counter the problem use a white reflector to bounce the light back into the eyes and face, creating a pleasing catchlight while you're about it

Eyes say more about a person than anything else, and unsharp and dead-looking eyes are a portrait-wrecker. Crisp and alive, they'll set you on the way to really successful people pictures.

THURSDAY

Capturing a personality

Even in the most unlikely situations you'll find that people are happy to be photographed. These fundamentalist Christians were heavily involved in praying at a huge gathering in the British Midlands, but my presence there was not only tolerated, it was encouraged. They were proud, and happy to be photographed, and their preoccupation gave me leave to shoot the kinds of pictures I wanted to shoot

Getting the eyes right is a technical matter, or rather a matter of technique – focus correctly and carefully, use reflectors to achieve a catchlight, and you're there. The other vital matter when it comes to people pictures – especially portraiture, whether formal or relaxed – is the atmosphere of the shot: whether or not you've caught the personality of the sitter, or at least whether you've put across what you personally feel about the person.

It's easy to dismiss this part of the process. After all, you can't do much about how a person looks, and all you're doing, surely, is recording that.

But consider this. If you were to write a few paragraphs about a person, you'd be giving your impression, wouldn't you? Another writer's impression may be completely different. Well, the same is true of photography – you have it in your power to completely change the way your subject is represented, you have the power to make them, break them or leave it up to the viewer to decide.

Nothing works as well as photographing people when they're engaged in their hobby, since not only will they be preoccupied and thus less wary of your attention, but chances are they'll be proud as well, and actually keen to be snapped. How's this for a happy face?

Still not convinced? Time for a story. There's a great portrait photographer called Arnold Newman, American fellow, Jewish too. That's relevant because one day he went to photograph a gentleman called Herr Krupp who made a lot of money during the war out of arms manufacture for Hitler. Newman lit Krupp with two flash lights from below his head-height, casting demonic shadows up his face – and if you look at how they light monsters in horror movies, that's exactly how they do it, from below.

So, unbeknown to Krupp, Newman had created a portrait of this man who he considered a monster, and he really does look like a monster. Result? One of the greatest portraits ever taken, and one very angry German industrialist.

The point is this. You don't just shoot what's there. You create an impression in your mind of what you want to say about the sitter, and you attempt to produce that on film. Rarely, if ever, will you photograph someone like Krupp, someone you feel unequivocal about, but you may photograph your dear sweet granny one day, your teenage rebel of a cousin the next and your boss for the company newsletter after that. Will you approach them all the same way? Certainly not.

Getting to know you

The trick, initially, is to get to know as much about the sitter as you possibly can. This applies particularly if you've every intention of making

51

a few bob by shooting some friends of friends, people in other words that you don't already know, but the creation of a rapport between you and your model can lead beyond that into a real relationship with the sitter.

Even if you just have one flashgun, you can still shoot studio shots. You can buy inexpensive stands that can take your gun, and then all you need is a large reflector to bounce the light back onto the subject, and you're away. The background in this shot was a sheet of cheap blue paper, hung in my front room

Why, though, would you need to create a rapport with your granny? Surely you're perfectly at home with who she is – you've even set her up at her kitchen table with some freshly baked cakes, because as we all know, that's what she's good at.

Indeed, although that's fine with you, what about her? People very rarely enjoy being photographed, and it's up to you as the photographer to make them feel at ease, to help bring out their real character rather than the false mask we all put on whenever a camera is taken out within 50 yards of us.

So start by talking before you go anywhere near your camera bag. Just talk – begin a conversation. Once you've got the sitter to relax a little, you can start discussing the shot you want to take. Explain things – tell them what you're doing and why, let them look at your camera gear, and try to match your approach with their personality while at all times being yourself.

Too often, photographers who are starting off in the rapport department think that all you have to do is crack a few awful jokes and say 'love the camera'. It doesn't work like that. The most successful photographers have their own style, they don't go into photographer mode, they are just themselves. Lord Snowdon, for instance, who is certainly one of the greatest portrait photographers in the world, photographs people in an atmosphere, as he puts it, of almost total silence. It works for him, and if you're not the jokey kind, it could work for you too.

On the other hand, you may be the gregarious type who likes a little mayhem around them. If that's the case, fine, but it should come naturally, because if you're not natural, the sitter never will be either.

Before you start your session, if you're shooting formally or semi-formally, you should have a very good idea of what type of pictures you want to take, you should have the camera loaded, the lights or reflectors set up, and you should have taken care of all the technical stuff. Your concentration needs to be focused on creating that rapport with the sitter and on getting their personality onto the film, not distracted wondering if there's a film in the camera in the first place, and if there is, which speed is it?

One last thing. Asking – or even ordering – people to smile never, ever works. If you want to shoot a smiley picture, make the sitter smile by being genuinely amusing.

It's the only way.

It's easy to simply shoot head-on when you're taking a portrait, but why not try some different angles? You can shoot the back of the head, for instance, or as here, go round the side and ask the sitter simply to swivel their face to look at you. The changes this brings don't absolutely alter the character of your portrait, but they do give you a different viewpoint

The portrait lens

Which lens is best for portraiture? There are no hard and fast rules – there rarely are – but generally, there is a length of lens that has become known as the portrait lens, and for very good reason.

On a 35mm camera, the portrait lens is the 80 or 85mm lens – something a little longer than standard (50mm) but nothing you could describe with a straight face as a proper telephoto. Why is this length so popular? Easy – it's perfect for portraits.

THURSDAY

Firstly, due to the illusion of perspective, the face is flattered by such a lens – with a wide-angle, the nose is accentuated, the eyes look buggy, and it's the kind of thing you want to use only if you're shooting people like Herr Krupp. But with this short telephoto, the perspective is flattened, thus making noses less prominent and features far more attractive.

That in itself is a good enough reason to make use of this lovely length (by the by, the short end of the highly popular 80–200mm or 70–210mm lenses will do just as well as a fixed-length optic), but there is another very good reason too.

You don't want to be on top of your sitter; you need some decent breathing space, as indeed they do. The 80 or 85mm gives you that breathing space, allowing you to get a reasonable distance away for a three-quarter shot or even a close-up, but without being so far away that you have to shout to be heard. It is absolutely perfect.

The fixed-focus 85mms have another asset, too. They tend to be fast – with a wide maximum aperture – and with portraiture that can be a bonus when you're trying to throw the background out of focus through selective depth-of-field (see Lenses and Accessories). With a wide-angle or a slower lens, you'll find that the obtrusive colours and shades of the background can easily take over.

Before you commit yourself to a portrait, it's worth considering whether you're after a full-face shot, a three-quarters or a full-length picture. This old farmer has a wonderful face, suggesting a close-up, but his interesting clothing demanded to be included too. The answer was a three-quarters shot that included both, and was close enough to give good details of the face and the clothes

THURSDAY

Using the background

Portraits often need a context which informs the viewer about the sitter, and the use of props and personal possessions is the best way to achieve this. A simple head-shot if this biker would have been pleasant enough, but by emphasising the bike you can give his personality the context it needs

Sometimes, of course, the background can be a vital component within a portrait. Environmental portraits – a shot of a trawler skipper on his boat, a shot of a nurse in a hospital – often use backgrounds to give information that otherwise may not be immediately obvious. Indeed, the background for any portrait can be used in this way.

A child in her bedroom with pop posters on the wall, your bookworm uncle in front of his bookcase, your mother in amongst her prize-winning flowers; props and backgrounds are often a vital signal when we're trying to capture a person's character.

For shots like this, you need to look towards the wider end of the lens spectrum, and make sure that your sitter is relatively smaller in the frame than a more standard portrait to avoid distortion of the features. And you'll need to be careful – your mother's garden may look wonderful, but a picture of her in it with a tree sticking out of her head won't. For that reason, it's often a good idea to scout round the location first, and decide exactly where you want the model to be.

Viewpoint

Lastly, don't forget the importance of viewpoint. A picture of a child may be more obviously shot from above – after all, they're little people – but if you shoot him on the same eye-level, you'll see a maturity that perhaps has been missing from the more obvious approach. Get below him and shoot upwards, and you have the makings of a very unusual portrait indeed.

It's easy simply to shoot from where you happen to be standing, but by getting up high or, as here, getting right down low, you can utterly change the mood of a picture. Children, especially, are rarely photographed head-on, let alone from below, so why not give it a try?

There is always a place for the wide-angle in portrait photography. Get into the thick of things, stick on a 24mm or a 28mm (the lens used here), and engage the viewer completely in the scene

You need to be aware of viewpoint for flattery reasons too – a high viewpoint will weaken the chin, a low one accentuate the nose – take your choice after a little experimentation and after looking carefully at the physiognomy of your victim.

Pictures of people aren't really about flattery, though. They're about creating something that really gets to the heart of the sitter. For that, you need a combination of patience, technique and a thorough understanding of human nature . . .

FRIDAY

LANDSCAPES

'Anyone can take an adequate landscape picture, but to do it well, you've got to love what you're looking at. A love of the landscape is vital, because if you don't love it, you can never really photograph it.'

Denis Waugh

Denis Waugh – a New Zealander based in Britain – is one of the world's greatest landscape photographers, extracting from the countryside such beauty that his pictures almost look as if they've been hand-tinted with watercolours. They haven't – but they originate from within him, and they're an extension of his love of the world, of his love of light, and his love of the landscape.

Of course, Waugh is in the happy position of having expert technique coming out of his ears, and so he can spend time on refining his pictures and his style. For the rest of us, before we can start to translate a love of the landscape into great pictures, we have to learn what's wrong with the ones that most of us take most of the time.

Often, it's rather less poetic than Waugh suggests, having more to do with photographic technique than a relationship with the land, important though that may be . . .

Time and shoe-leather

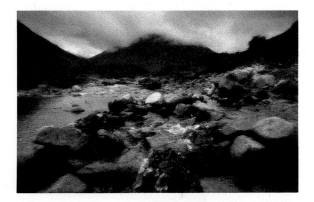

Great landscape photographs are rarely taken from the car – you need to explore to find the very best positions to shoot the landscape from, even if that means getting your feet wet. The use of ISO1000 film with a soft-focus filter gives this landscape its misty, atmospheric feel

FRIDAY

The key word for a landscape photographer is patience. The landscape may seem like an unchanging, primeval force, and so it is in the sense that you could wait a week, a year, a decade and nothing much will happen to the mountains and valleys, the rivers and lakes. What will change, however – a hundred times a day, a thousand times a week, a million times a month – are the light and the character of the landscape. And that's why patience is such a virtue.

Most disciplines within photography are, when you boil them right down, about **light and composition**, but never is this more true than with landscape photography. With the landscape, there is no action to capture as there is in sport, no facial expressions to convert to film as there is with portraits, no animal to understand as there is with wildlife photography. The landscape is there, to be interpreted in the way you choose, and those two elements – light and composition – are the main weapons in your armoury.

Both things use up time – you need to wait for the right weather, the right light – and they use up shoe-leather – you need to get out of the car and walk, walk, walk . . .

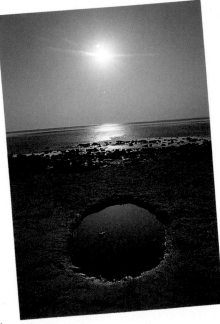

Don't assume a landscape will look best when you use a landscape format – why not turn the camera on its side and shoot a portrait format landscape? When shooting into the light, as here, knock down the power of the light with a filter, preferably a grey graduate, otherwise the foreground will underexpose into a black mess

FRIDAY

Linking the foreground to the background

One reason so many landscape pictures fail is because, awed by a vista, we lift the camera to our eye and shoot what's sitting right in front of us. The result, sadly, is often pictorially as dead as a doornail, with a featureless sky taking up half the picture, a lifeless landscape filling the rest.

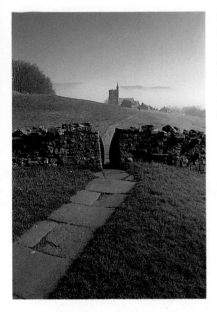

Linking the foreground to the background is often the very essence of good landscape photography, and you need to use anything at your disposal to achieve that link. Few things are better than a winding path . . .

The first thing to do, then, is liven up the composition, and the best way to do that is by linking the foreground to the background. This not only gives a sense of scale to the landscape, but – and this is absolutely vital to grasp – it also leads the eye into and around the photograph. The result is a far stronger composition, and by extension, a far stronger landscape photograph.

It could be a tree or a bush; it could be a stream or a lake; it could even be a sheep grazing lazily in a meadow – but there must always be something to give the landscape depth, and that something should should be just in front of us.

So, leave the car and start walking. It won't be long before you find an appropriate something to interest the eye and lead into the shot. Often, turning the camera on its side will help enormously – just because the landscape seems to demand that you shoot in the landscape format (wider than it is high), often you'll find that using the portrait format (narrower than it is high) will in fact work much more successfully.

FRIDAY

Light works

If it takes time to achieve the right composition in a landscape, it takes much longer for the light to be right. The time of day and, just as importantly, the time of year, will affect the light on the landscape greatly, and you need to be happy about the light before you come anywhere near to tripping the shutter.

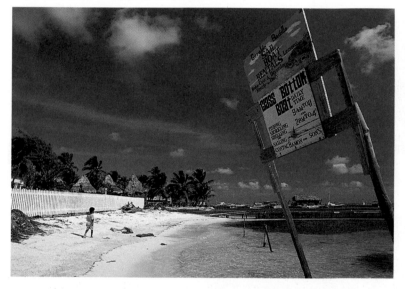

Beach and sea-scapes, as well as snow-clad mountains, can confuse camera meters terribly. Seeing so much whiteness, they automatically underexpose, causing grey snow and muddy-looking sand. For the best effect, increase the exposure by about two stops, and the scene will reproduce as you saw it, which, after all, is what you want

On a long-term basis, it's a good idea to have a number of locations in mind, and to return to them at different times of the year and under different lighting and weather conditions.

May and September evenings are generally considered to have the most subtle lighting for portraits, and evening is considered by many to be better than dawn, since the sun rises on a cold landscape, but sets on a warm one, making the light extremely attractive.

Dawn and dusk give the landscape a completely different atmosphere, and are most certainly not interchangeable, although both are preferable to **midday**, when the light is as dead as it's possible to be – high in the sky and unrelentingly drab.

FRIDAY

With a low sun, either in the morning or evening, you get low, dark, deep, mysterious shadows that bring the landscape alive – which is exactly what you're trying to do.

If you live in the country, of course, experimenting with all sorts of times of the day and the year is easy enough, but if you're simply on a day-trip, you have to make do with what's there when you're visiting. It will change throughout the day – even if there are slate-grey skies and no prospect of change on the horizon, it's a rare day that some light doesn't come peeking out through the clouds. Here, the use of **tripod** is a good idea. Not only will it help you with your composition (it slows you down, always a good thing, as well as allowing you to get into positions, both high and low, that you'd find difficult hand-holding), but it will also give you the patience to wait for the right light.

But what *is* the right light? Surprisingly, a cloudless day with strong sunshine is probably just what you *don't* want, since the character of a landscape is revealed much more lucidly if there are clouds and weather-fronts zipping about the place. The finest light, without a shadow of a doubt, is **just before or after a storm**, with the sunlight streaming onto the hillside and black clouds behind it, and in front of you. You may get a little wet in the process, especially if you're stranded in the middle of nowhere, but the results will magically speak for themselves.

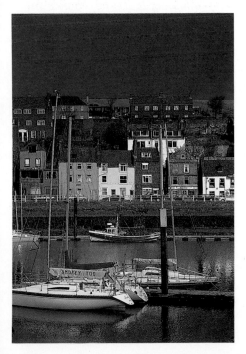

Human beings are forever encroaching on the landscape, so don't ignore our own handiwork. This is an excellent example of the finest landscape weather – sunlight the foreground, a dark, brooding stormcloud behind

FRIDAY

The best time to shoot landscapes is when the sun is low – either at dawn or as the sun slips down at sunset. This was taken at sunrise, a good example of the beauty of the light at that time – only a soft-focus filter was used, the colour is Mother Nature's own

Landscape photography, then, is rather like fishing. Catching a great picture is obviously a lot of fun, but there's also joy to be had from just sitting there, watching the weather change, watching the sun go down, watching how the landscape's personality is affected as the elements move around it. If you don't enjoy this aspect of it, stop fishing. There is absolutely no point in rushing a landscape – the results just won't be worth looking at.

If you want fast action, and immediate results, the landscape is not the place to look.

Using filters

In any good landscape photographer's gadget bag lurk at least a few filters – though not the crass kind, like the coloured graduated filters that hit the peak of their popularity in the early 1980s and made every sky purple, red or orange. They served their purpose as a novelty, but never really added much to photography, and have since fallen – thankfully – out of favour.

The trick with using filters in landscape photography which is about capturing the purity of the world around us, is to make sure it doesn't look like you've used them. So why use them at all? Because, quite simply, they can turn a good landscape picture into a great one.

FRIDAY

The most useful, some would say vital, is the **grey graduate** – a piece of resin, usually square – that is clear at the bottom and graduates to grey at the top. The reason it's so vital is to do with contrast control.

As we mentioned in Tuesday's discussion on light, film just can't cope with the range of contrasts that our eyes take for granted, and there's precious little on God's earth as contrasty as a landscape – the difference between the land and the sky can be anything up to four or five stops.

So you're left with a choice – you either expose for the land or you expose for the sky. In the first case, you get a white featureless mass in the sky, no matter how beautiful the clouds looked; in the second, the green fields go a muddy grey and you can't make out whether it's a farmer or a tree in the foreground. Stalemate.

Well, not quite – enter the grey graduate on its white charger. Simply purchase one of these inexpensive little accessories, take your meter reading before you attach it to the lens – if you take it afterwards, the foreground may be burnt-out – and then position it so that it darkens the clouds. The result will give you the best of both worlds; a well-exposed sky and a well-exposed foreground – the essence, the very first starting block, of good landscape photography.

Some newcomers to landscape photography don't understand what the fuss about the sky is – surely the meat of the shot is in the landscape, not up in the clouds? Wrong – not only to you need the sky to give the land a perspective, but skies in themselves can be astonishingly beautiful, adding to the interest of the shot and, just as important, helping you with the composition if the cloud formation is right.

Always bear in mind the huge difference in brightness between the land and the sky. Without a grey graduate filter, you have to choose between one or the other – expose for the land, and the sky burns out, expose for the sky and the land turns black. With one, though, you can have detail in the clouds and the land, a happy compromise. Note the slightly pinky tinge the grey graduate has given the sky. This can happen with certain film types, and is not usually too unattractive. If you find it is, switch brands

FRIDAY

The other filter you should have is some kind of a **warm-up** – the 81 series comes in different strengths, from delicate straw to downright yellow – to add an overall warmth to the landscape that even late evening sunshine may not provide. Warm light is the most attractive, and if you haven't got it to hand, you can always manufacture it by using one of the 81 series.

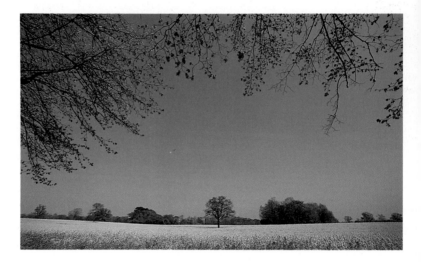

When the sun is bright during the day make the most of it by accentuating colours with a polarising filter, hiking to a rape field and including acres of bright blue sky. Note the use of the overhanging branches to avoid the top of the shot being featureless and boring

Water, water

Finally, you may want to throw in a **neutral density** (ND) filter, which will cut out the light without affecting the final result. The reason is simple – blurred water looks wonderful.

It's a trick that's been used a lot, but is none the worse for that. Simply set up a tripod with a stream in the foreground and set the shutter speed to about half a second. That may be hard if the light is strong, which is where the ND comes in, but if you can manage it, the rushing water, blurring to a mass, will look spectacular.

Indeed, **water** is often a vital element in a landscape. Not only does it look wonderful if you use the blurring technique, but it can help to draw the eye into the picture, aiding composition, and – if it's still – can mirror

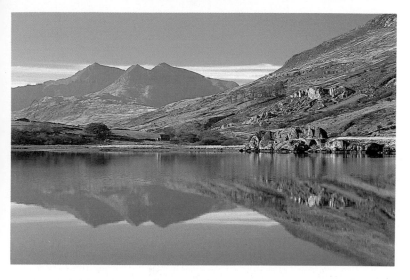

If in doubt, hunt down some water. It not only can add dynamism to a shot (as in a running stream), but as here it can mirror the natural world beautifully. Any lens is good for landscape, depending on the subject and what you want to convey. This was shot with a 300mm telephoto

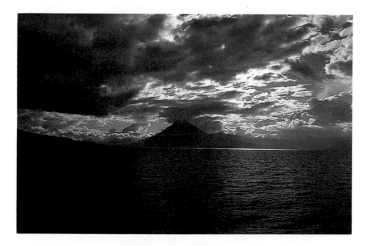

A landscape picture doesn't have to include very much land at all – not when the sky is dramatic (and helped along by a grey graduate filter) and the bit of land is a volcano like this

the mountains creating a harmonious photograph. Last but not least, even fast-moving water will reflect the light in the sky, adding tone, contrast and colour to the shot.

Water in any form, streams, rivers, lakes, the sea, can do your landscapes nothing but good.

Human elements

Don't be frightened to include some of **humanity's handiwork** in your landscapes – after all, there are very few landscapes left which can purport to be as nature intended, and humanity has been adapting the countryside since the stone age.

A telegraph pole, pylons, houses, walls and fences can all add interest and, as we've already learnt, they can come in mighty useful for aiding composition.

Finally, there are people themselves – just as we have adapted and changed the landscape with things like pylons, so very few country scenes are completely devoid of people. Indeed, not only are landscapes with people in them honest mirrors of the world we live in, they can also help you add a human dimension, and therefore perspective, to the shot. A lone hill-walker in an orange waterproof can give a huge mountain the perspective it needs to come across as truly awesome.

Landscape photography looks as if it's by far the easiest option – all you need to do is head for the wide open spaces, unpack your gadget bag, and you're off. The truth is far from that. You need the patience to wait for the right light, the time to work on the composition, the technical knowledge to use, for instance, a grey graduate if you need it, and finally, as Denis Waugh says, you need to love the landscape . . .

Simple, clean and direct, this is a classic seascape, beautifully executed. Fujichrome 1600 film was used with a polariser to give the depth of colour

SATURDAY

HOLIDAYS AND TRAVEL PHOTOGRAPHY

'Always remember you are a visitor. Be respectful at all times of other cultures. It is extraordinary how kind and amenable many people are to travellers, and common courtesy is the least we can repay them with.'

Patrick Lichfield

Holidays are when people really start burning up film, and even those who shoot but one roll of Kodacolor a year will have at least a couple of holiday snaps on there somewhere – in between the Christmas trees. The freshness of the surroundings, the exotica all around, the time available to spend shooting pictures – everything conspires to make holidays the perfect opportunity to get really stuck into some serious picture-taking, which is exactly what most photographers, whatever their ability, proceed to do.

With this in mind, then, a simple question has to be asked. Why – with so much time, so many new sights, so many fascinating subjects – are other people's holiday snaps often so utterly tedious? And why, by extension (though we hate to admit it), are our own holiday snaps so utterly tedious to other people? What on earth has gone wrong?

How people react to your presence with a camera depends very much on the culture of the place you're visiting, as well as exactly what they're doing. This Japanese gentleman, in common with nearly all his countrymen, actively encouraged me to photograph him. A beggar in an Athens street will have a very different view of things, so always assume that you're not welcome to take pictures, and approach subjects with restraint and civility

67

Be prepared

The problems start before you even leave your house. You know the feeling. You're hundreds of miles from home, presented with the most breathtaking vista you've ever seen, a view that simply demands the use of, say, a nice soft-focus filter. Sadly, that filter is sitting smugly in a drawer in the living room back home.

Or you're proudly showing off your holiday pictures to a group of friends when someone quietly asks whether you turned up a side road right by your hotel and saw what sounds like the eighth wonder of the world. Embarrassed, you mutter that you didn't.

The moral of these tales is simple – be as prepared, in every way, as you can possibly be.

Festivals can not only offer some great photo opportunities, but can also give a flavour of a long-gone culture. Rice-planters in Japan no longer wear these photogenic hats, except, that is, for the famous Rice Planting Festival, which takes place once a year in Kyoto. I made sure I was there, rearranging my schedule to be in Kyoto that day

Preparation for travel splits broadly into two categories: photographic and non-photographic. The latter will enable you to have a much better time when you're away, the former will help to take some great pictures while you're there.

SATURDAY

How to enjoy a holiday

It is virtually impossible to spend too much time finding out about the country or region you're going to visit when you go travelling.

Read and inwardly digest everything you possibly can about the places you're likely to come across – and make notes about them. Sneak into bookshops and have a look at the large, attractive, glossy coffee-table books covering your destination, and make notes of the angles, the viewpoints, the light and the compositions that the photographers have used. If nothing else, you can rest assured they've had the time to find out the very best vantage point for a shot, say, of the Taj Mahal – a vantage point you may never find if you stayed in India for a month.

When you head for somewhere famous, bear in mind that everybody's already seen the shot from the obvious viewpoint. So try something a bit different, and take your time trying to see things afresh.

Here are three ways to shoot the Taj: using a 17mm from a low viewpoint, a more standard shot from the front, and a detail of the inlaid marble

69

SATURDAY

Talk to friends and acquaintances who've been there before you, and beg to see their pictures, no matter how happy-snappy they may be; at the very least, they'll give you an idea of exactly how you *don't* want to shoot when you get there.

A call to the country's **Tourist Office** is always worth the trouble; they'll send you brochures, leaflets and information that will add to the picture you're building up of the place. As well as reading about it, finding out the interesting places to visit, the sights to see, the customs, festivals and fast days, it is – as ever with photography – vital to *look*.

Look at the photographs of the country – they won't all be masterpieces, but the more pictures of the Leaning Tower of Pisa you see, the more prepared you'll be when you get there to approach it with a firm idea in

Keep an eye out for local colour: a touch of underexposure added a depth of colour to these Mexican rugs, contrasted with the green wall. I later saw a notice in this Mexican village that read 'anyone seen taking pictures in the village goes to prison for one month'. Luckily, nobody saw me, but the camera was stuffed back into its bag with unseemly speed

mind. If the majority of shots, for instance, seem to be from a certain angle at a certain time of day, that is no coincidence; it's because that's the time when the place is at its most photogenic, and avoiding other times of day and other vantage points will save you much wasted shoe-leather when you reach your destination.

The importance of reading and learning about the country – through fiction as well as the ways described above – can't be overestimated. To really make the most of your couple of weeks in a country, you need to be one step ahead when you hit that airport.

If you've talked to people and become a human dustbin for information, you'll know how the locals react to photography, you'll know whether film is available in case you run out, you'll know the most photogenic places to go, and you'll know the best way to shoot them. This is the kind of information that will lead, ultimately, to a roomful of friends and relatives not actually falling asleep in your slideshow.

For that reason, above all others, it must be worth it!

What colour is the Leaning Tower of Pisa? It depends on the time of day you shoot it – during the afternoon it is more like the white we associate with it; later in the evening, a rosy hue takes over the famous building. Holidays can be so breathless that you simply don't make the time to hang about and see how the sights change their character – doing so will make your shots much more varied, and, with any luck, more interesting

How to take great pictures on holiday

While the non-photographers in your travelling party have the luxury of just reading and learning about the area you're visiting, as photographers, we have an extra job to do – to prepare things photographically.

Photographic preparation, firstly, involves thought about exactly what sort of pictures you want to shoot.

If you're going to shoot the beach, make sure it's from a safe distance – like the top of a hill, looking down! Sand, sea and salt-laden wind are the enemies of cameras, and it's just not worth the risk

Happy on the beach snapping the kids and perhaps the deckchair attendant? Fine, take a compact camera – preferably an all-weather or waterproof one – and a plentiful supply of film, and you're set. Want to return with not only a fabulous selection of slides, but perhaps a handful that you could sell to travel magazines or an agency? Then you need to construct the perfect travelling camera bag: it has everything you could possibly need secreted within it, but mustn't break your back if you have to walk a few hundred yards up a mountain. To achieve this blissful arrangement, you have to make some compromises, but not as many, in fact, as you may have thought.

Watch your weight

The **weight** of your camera bag is actually a serious matter – not only can taking a too-heavy bag exhaust you as you trudge round supposedly having a good time, but you can easily damage your back or neck, and will certainly do your posture no good at all, with all the weight on one shoulder. (Remember that you'll be doing a lot more walking with that bag than you're used to.)

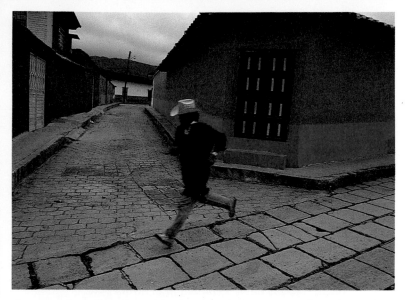

A person in a shot can add a human element, as well as dynamism. I waited for ten minutes, having seen the lovely colours in this Mexican street, until a conveniently-hatted local ran past

The answer, then, is to clear out your gadget bag, put your camera(s), lenses, bits and pieces in front of you, and carefully and thoughtfully make up a bag that's ideal for travelling.

If you own two camera bodies, it's best to take them both. Not only does this offer the option of a back-up should one fail (and the avoidance of bank-breaking repair fees from the local photo store), it also gives you far greater flexibility.

One can be loaded with black and white film, for instance, the other with colour. Or one with fast film, say ISO1000 for those grainy images, the other with ordinary ISO100 stock for everything else. Or one could be your wide-angle camera, the other have a medium-telephoto attached for the odd portrait that may happen along on the way. These options will save you time and trouble when you're presented with fast-moving and fascinating scenes – scenes you hope to encounter every day.

Apart from possibly taking two camera bodies, most travel photographers agree that the trick is to pare down your equipment as much as possible, while acknowledging that you shouldn't see yourself short. The one-body/two-body debate is a classic example, but my advice is to take two along – you can always leave one at the hotel (in the hotel safe, of course, not in your room!) if you just can't face carrying both around.

If you have room in your bag, a Polaroid camera can help smooth your passage – here a photographer snaps a Kenyan woman who was delighted with the instant print, and allowed him to shoot her to his heart's content afterwards

Lenses and bits and bobs for travelling

The next vital decision is which **lenses** to take away with you. Clearly, unless you really have an arsenal to choose from, you'll be taking along most of the lenses you own. Remember, though, that whilst that 300mm seemed like a good idea at the time when you snapped it up at a bargain-basement price, are you really going to use it on your trip to Greece? If so, what for?

And that 16mm fish-eye, attractive though the odd shot can be – is it really going to earn its keep on a trip away from home? There is a simple rule to abide by when you're making these decisions: if you can't see yourself using a lens or accessory at least once a day, then leave it at home. You won't regret it.

Accessories, small and harmless though they may look, can easily become the heaviest things in a gadget bag, so give them a lot of thought. Sure, that multi-starburst diffraction filter that makes everything go green and sparkly can produce some pretty crazy effects; but since you've only ever used it once, will you really use it on holiday?

Filters should be limited to the ones you're most likely to use: a skylight or UV permanently on every lens for protection and the cutting out of UV rays, a polariser to deepen skies and add lustre to colours, a warm-up to take the blue out of mountain scenes and add depth to sunsets and evening light; a grey graduate to knock down the contrast between the sky and the land; and one or two of your own favourites.

SATURDAY

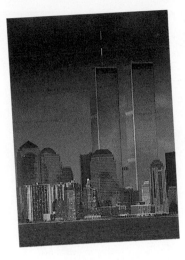

The Manhattan Skyline – one of the most famous sights in the world. In an effort to try something different, I used a very fast film (ISO1000), which gave large grain and muted colours to produce this painterly feel

Other bits for holiday shooting

What else to take? A small flashgun is worth its weight in grabbed opportunities, and if you can bear it, a tripod is always a good investment – a small table-top one will do, along with a cable release. (If not, how about a bean bag to rest the camera on? They act as a poor person's tripod and can double up as a pillow for long journeys.)

Throw in a cleaning kit – soft cloths, a blowerbrush, perhaps some compressed air – and as many films as you can afford (they may be unavailable, out of date or very expensive where you're going), and you're set for your trip. Pack it all neatly in your bag, with the films in a clear plastic bag (it's better for officials at airports who you've asked politely to hand-search your films), and you're off.

Problems with shooting on holiday

Question: Which things on this planet do cameras and films hate more than anything else?

Answer: Heat, sand and salt water.

Moral: When shooting on holiday, be careful.

The cardinal rule is that unless you have a weather-proof camera, *don't* take your gear to the beach. Apart from the fact that intense heat can spoil the film, there is sand – one particle in a camera's mechanism can wreck it for life – and salt-laden wind, as well as water. Taking pictures at the beach is like walking through a minefield with a blindfold and skis on, and if you can possibly avoid it, then do so.

Beware of the bright sunlight that so often accompanies a trip abroad. By asking this Indian labourer to step into the shade, away from the beating sun outside, I could control contrast and exposure much more easily. He asked for a print, as many people do. If I think I'll be unable to, I make it clear that I shoot slides and that getting a print to them will be hard. Usually, they understand that you'll try your best

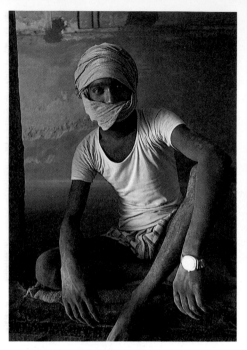

There are other problems, too. Although modern emulsions are hardy against **heat**, keep your films out of direct sunlight and out of the car when you're not in it, and if there's a fridge in the hotel, it does no harm to pop them in there until you need them (give them a couple of hours to defrost before shooting). Generally, you'll find heat much less of a problem for films than has been the case in the past, but better safe than sorry.

Because the inhabitants of this shivering little island have one mission when it comes to holidays – going somewhere hot and sunny – the sun is likely to cause a few problems to your picture-taking, too. With white-washed buildings, sun and sand, **flare and glare** will come between you and sharp, crisp photographs. Always use a lenshood, and keep your lenses as clean as possible and you'll cut down the problem by 90 per cent.

The glare may cause **exposure problems** though – if there are white buildings about, or if there is flare from a silver sea, bear in mind that the picture may be underexposed and come out too dark – the same happens when you're shooting in snow. To avoid this, add a stop or two to the exposure (use f/5.6 instead of f/8, say), or better still, bracket either side of the meter reading to be sure that one will be accurate.

A word of warning

Travel does bring out the photographer in us all, but that has a negative side, too. Because everything's so new and exciting, we tend to machine-gun the scene, somehow expecting the smells, heat and excitement to miraculously transfer to the film. They don't. Travel pictures need as much care and forethought as any other kind of pictures – often more.

Once a subject has made it clear he's happy to be photographed, don't be frightened to ask him to move a little bit for the sake of better picture. I saw that this plain wall would contrast well with the Guatemalan's wonderful costume, and asked him to stroll 50 yards up the road to stand in front of it. The danger is to panic, snap and move on, but taking your time never reduced the impact of a travel picture

And Lichfield's warning should be taken into account, too. Being photographed is not many people's idea of fun, and all too often we assume that the picturesque inhabitants of the countries we visit are just more tourist-fodder. It hardly needs to be said that they're not, and that they deserve to be treated with respect and dignity. Apart from anything else, it is virtually impossible to take a good portrait of someone who's vehemently against the idea, and shooting from behind a tree with a long lens simply wastes film.

Bearing these things in mind will take you a long way towards the wondrous travel shot and away from the dreary snap, and it will provide you with pictures that actually do your globe-trotting justice.

SATURDAY

Whether to give money to a subject if they ask is entirely a personal matter. I rarely do, as I feel that money will scarcely help them feel any more dignity about being photographed. But this Guatemalan woman was so photogenic, and the light so nice, that I broke my own rule and accepted a financial deal with her. Had I bought one of her rugs, it would have been much the same deal, of course, but the overriding ractor is that people who really don't want to be photographed rarely make good subjects, and their tension seeps onto the film

If you're interested in selling your work to magazines or brochures, always be aware that they may need to lay text onto the shot, especially if it's front-cover material. With this in mind, I left enough space above Mount Fuji for the title of a magazine to be fitted at the top of the frame – something which happened shortly after my return, paying for the rather expensive train fare from Tokyo to the famous mountain

SATURDAY

Tips for travellers

Batteries Always take a spare set with you.

Buying camera equipment abroad can not only mean hefty import duties on your return, but you may find that the warranty is invalid or – as often happens in the Far East – the camera is a fake.

First-Aid Take a little first-aid pack for yourself and your camera.

Insurance Check whether your camera is covered for travel – and get it covered if it isn't.

Local processing is best avoided, mainly because you just don't know the processor, not because it will automatically be awful; wait till you get home.

People are not always happy to have their picture taken. It's best to ask – snatched, surreptitious pictures rarely work – and to walk away if they're unhappy. You'll never get a good picture unless you have the cooperation of the sitter.

Prison Stay out of it by never photographing police stations, army installations or airports – even civilian ones. If you have an interest in planes, for instance, find out from the country's Embassy where you can and can't photograph.

Sea If your camera drops into it, wipe it off with a damp cloth and get it to a repair shop immediately; the corrosion starts before you've even yanked it out of the water.

X-rays affect fast film (over ISO800) more than slow films, have a cumulative effect (the more times a film goes through, the more likely it is to be fogged) and affect exposed film more than unexposed film. If possible, ask for a hand-search, but don't push it, especially abroad.

EXPOSURE AND COMPOSITION

'You should use your exposure meter only as a guide, and you should get to the stage where you can tell the guide it's wrong if you feel it to be wrong. There's no such thing as a "correct" exposure.'

Helmut Newton

'Everything has to be in place – it's a combination of many things. If a picture is unbalanced, then it won't work. If it's badly composed, then it's no picture.'

Elliot Erwitt

Exposing yourself

If photography is all about light – and frankly, it is – then the measurement of light is perhaps photography's most important technical matter. Since photography was invented, the simple problem of getting the right amount of light onto the film has preoccupied the scientists, and as metering systems have become more and more sophisticated, it would seem that the problem is receding towards the horizon.

Unfortunately, in reality, it's still right in front of our faces.

A classic exposure problem – a dark face, backlit, and with no flashgun or reflector to help the photographer out. What to do? Well, I simply went in very close to the boy's face, took a reading, and then changed nothing when I went back to my shooting position. A little judicious bracketing either side of what the meter told me was also called for, as the margin for error with a shot like this is tiny

SUNDAY

The trouble is that the scientists who program camera metering systems have to have some kind of a bench-mark, something that the system will always assume is normal. For the best part of a century and a half, they have taken a light grey – termed 18 per cent grey – as their bench-mark, a grey that has a tonal range typical of the average scene. And since most scenes are indeed average – they wouldn't be average otherwise, of course – this often works out just fine. The 18 per cent grey is very similar to human skin in its tonality, so with a typical portrait, taken in the shade, with a brick wall as a background, and with the subject wearing a neat grey suit, you can stick your camera's meter onto automatic, manual, program, anything you want, and you'll take a perfectly exposed picture.

When presented with an impossible exposure situation, experience is all you have to fall back on. For this shot, the photographer had to expose correctly for the cars' light trails, while a camera on automatic or program will insist on exposing, or trying to expose, for the mass of land around the road. The answer is to try it a few times until you get it just right – an exposure of about a minute at f/5.6 is a starting point, but shoot at various exposures to be sure. After all, you're only after the one shot, and you've taken the trouble to go to the motorway bridge, so it's best to get it right

Difficult situations

Often, however, you're not presented with such a friendly scene. You'll be shooting in sunlight, or with shafts of light pouring into a dark church,

or the person will be wearing black, or white, or they'll be standing on white sand or black tarmac – many a situation will come nowhere near to an 18 per cent grey. The trouble is that the camera will want to reduce it all down to that tonal range, and you'll end up with an over- or under-exposed shot.

Sounds a little unlikely? Let's take a couple of common examples.

Being selective

The first is a shot of your cousin on her wedding day. She's wearing a stunning pure white dress and she's standing in the doorway of a church, with the cool, dark interior behind her but with the sunlight streaming onto her from behind you. Oh dear, this situation can safely be described as contrasty one – in fact far too contrasty for the camera and film to cope with without your help.

So stop and think. Think *subject*. Your subject is what's important, but the camera doesn't know that. Seeing all that blackness taking up much of the frame, it will assume you want to get some detail in the church's interior, so it will try to expose for that, reproducing it as a muddy 18 per cent grey, resulting in your bride being over-exposed into a whiter-than-white blob that looks like something out of Close Encounters Of The Third Kind.

What the camera has done for you is given you a guide – and it's time to tell the guide it's not telling you the whole story.

Shoot this as the camera would like you to, and you'd have a horrible mass of nothing. Take a reading from the highlight, the shaft of sunlight, though, and you have a lovely picture, perfectly exposed. The difference – isolating your light-source and exposing for the right part of the shot – is the essence of photographic exposure

SUNDAY

Never forget the weapon that is your flashgun. Fill-in flash (see Understanding Light) is always a useful tool in cleaning up shadows and revealing detail

There are a number of options open. You could, if you have the experience, simply guess how much exposure the bride really needs for the delicate embroidery in the dress to come out and the church's interior to fade to black – in this situation, you'd probably need to decrease the exposure by about two stops. (Closing down to f/11 from f/5.6, say, or increasing the shutter speed from 1/60sec to 1/250sec.)

Alternatively, you could bracket your exposure, simply shooting several shots at different exposures in the hope that one will be right. This is a good tack for many situations, but not terribly effective with people pictures – the perfect exposure may be the very frame that has the bride with her eyes closed.

Or you could go in close, filling the frame with the dress or the bride's face, locking the exposure there and changing nothing when you return to the taking position. Or, to save your legs, you could attach a long lens and zoom in on the dress, taking the reading and again changing nothing when you switch back to your taking lens. (You'll either need to switch your camera to manual mode, or lock it on automatic if that's not an option.) Or indeed, if your camera is the proud possessor of a wondrous spot-metering facility, simply switch to spot and take your reading like that.

The final idea would be to change from what you're doing – taking a reflected reading of the light bouncing off the scene and coming into

SUNDAY

Shooting at night is notoriously tricky when it comes to exposure, so you'll have to experiment. For a fairground, especially, all the flashing lights may well confuse your camera's meter, so start with an exposure of about 1/15sec at f/5.6 with ISO100 film, and bracket as much as your pocket will allow

your lens – to taking an incident reading of the light that's actually hitting the subject. The best tool for this job is a hand-held light meter which takes an invercone over its light-sensitive cell, which you then point at the camera (not the light source) from where you want to measure the light.

Often, you'll find that the reading is very different from the one you've taken with your camera, but that's because your camera is woefully mistaken.

The same situation as your bride conundrum, in reverse, rears its head when you visit the beach to take a few shots of your child playing in the sand. The sun reflects off the beach and the sea, and the boy's face is tanned by days of sunshine.

In the situation, with so much bright light around, the camera will panic and try to reduce the beach, the sea and the little boy to a mid-grey, the old 18 per cent again. So open the aperture a couple of stops (f/4 instead of f/8) or decrease the shutter speed (1/60sec instead of 1/250sec) to allow the light that the boy's face needs to be anything other than pitch black to reach the film. Use the same techniques, and you'll be fine.

Eventually, you'll develop a feel for whether your camera's meter is telling you little white lies or not. In most situations, you can trust it, but when there is back-lighting, contrast or large areas of very different tonal ranges and colours within the scene, you can rest assured that you'll need to help your camera out a little bit.

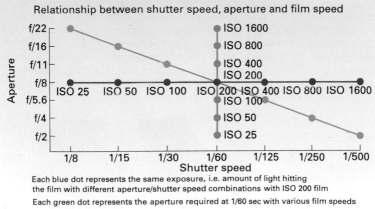

Relationship between shutter speed, aperture and film speed

Each blue dot represents the same exposure, i.e. amount of light hitting
the film with different aperture/shutter speed combinations with ISO 200 film

Each green dot represents the aperture required at 1/60 sec with various film speeds

Each red dot represents the shutter speed required at f/8 with various film speeds

Clever, but not clever enough?

Some modern autofocus cameras are so highly developed that they will
expose, even in the trickiest situations, for the subject you've focused on.
What they can't do, however – and probably never will – is make artistic
decisions.

*There's no such thing as 'correct' exposure. Normally, this would
be considered a little dark, but the deep shadows work to the
photograph's advantage, so I underexposed by a stop, and it
succeeded*

As you'll see if you bracket a scene three or four stops over and under, there is no such thing as correct exposure. A portrait can be enhanced by deliberately underexposing, making it much more moody, for instance – and the decision to do this has to be taken by you, the photographer. By all means leave your camera on automatic or program modes most of the time when happy-snapping, but when you're trying to invest the pictures you take with the benefits of your own decisions, you'll have to do the thinking for both yourself and the camera.

By uprating ISO100 film to ISO400, and asking the lab to 'push process' by two stops, you get very contrasty, punchy results. The highlights, as here, sing out beautifully, while the shadows remain deep. You can't do that normally – you have to choose one or the other – so experimenting with films is always a good idea

Composing yourself

Riddled with rules, cluttered with clichés, learning about composition can seem to be more trouble than it's worth. The fact is, however, that sloppy composition can transform what would have been an intelligently thought-out photograph into one that deserves simply to be swiftly placed in the file marked bin. Composition – the arrangement of elements within the frame to form a pleasing (or deliberately unpleasing) whole – is vitally important to good picture taking.

SUNDAY

Simplicity, said the great Henri Cartier-Bresson, is the key to photography, and while few of us will ever attain his heights, his advice is worth considering whenever we go looking for pictures

It's your way of making the viewer of your pictures look where you want them to.

Few pictures rest entirely on their composition – although some by the great Henri Cartier Bresson come pretty close. Usually, composition is merely an element within a photograph that also has good lighting, an interesting subject matter, spot-on exposure and all the rest going for it too. Composition is not, however, something you should relegate down the list of things to take into account. In a way, it should be the first thing you think about.

Cartier Bresson managed his miraculous compositions largely by simply waiting for the elements in his viewfinder to come together and work as a composition, a tactic he described as waiting for the Decisive Moment. And this simple philosophy can stand you in good stead, because all too often, we see something we want to shoot and – plonk – we shoot it and move on.

By *waiting* and, more importantly, really *watching* as things move and change within the viewfinder, we can find something akin to that decisive moment in which the composition comes together. In all but the most static picture, things are changing all the time, people walk into shot, trees blow in the wind, a dog turns to us and yawns – these things will affect the composition entirely.

Watch your viewpoint

There is more to composition than merely waiting, however. There are many decisions you can take that will affect the arrangement of objects

and subjects within the frame, and perhaps the most important of these is – are you shooting from the right place?

Most photographs are taken from between five and six feet off the ground – because that's where our eyes happen to be when we're standing up and we fancy popping off a frame. But who says that's the best place to shoot from?

Perhaps the scene needs a different **perspective** – maybe you should lie on the ground for that picture of the family, maybe you should shin up a tree or stand on a wall for the shot of the flock of sheep. Choosing your viewpoint should be one of the first choices you make, and it should involve a lot more thought than simply lifting the camera to your eye and snapping a picture. Professionals often have a stepladder in their studios for exactly this reason.

Robert Capa, the great war photographer, said that **if your pictures are not good enough, you're not close enough** and it's true that many pictures can be mightily improved by simply taking five paces forward towards you subject. Getting rid of those acres of meaningless space around the subject will not only draw attention to that subject but will in itself tighten up the composition no end, resulting in a much more powerful picture.

Try it, it works.

Composition often means simply going in closer – it was the great war photographer Robert Capa who said, 'If your pictures aren't good enough, you're not close enough'. You may have to take your shoes and socks off and get your feet wet, but it will be worth it!

SUNDAY

Using lenses

Your lens choice is important, too, in composing your pictures. If you're using a zoom, then use it to watch how altering the focal length will change the composition. Without moving, you can crop out intrusive bits and pieces from the frame. The longer focal lengths will allow you to pick out your subject, perhaps throwing the foreground or background out of focus and concentrating the viewer's attention where you want it. Planes can be heaped one on top of the other, creating broad sweeps of colour and tone.

Indeed, colour and light are vital elements within a photographic composition. The eye is automatically attracted to bright spots of light and colour – imagine a red poppy standing in a sea of green grass; you're eye is immediately attracted to that tiny poppy, simply because of its colour.

Light and shade are important, too. Be sure that if there are stray light spots within the frame they aren't attracting too much attention, and that if your subject is in the shade, then it will of itself overcome that and not be the secondary element – unless you want it to be. Use shadows as compositional tools as well – they can distract or attract the eye, depending on how you use them and where you place them in the frame.

Foreground interest is vital in creating a composition with vitality, so make sure there's something to lead the eye into the picture. Bear in mind that you'll need a smallish aperture to get it all sharp, and consequently a tripod to steady the camera with the resultant slow shutter speed

Wide-angles can help you with dynamic compositions. Here a 21mm was used to accentuate the powerful foreground. Without the powerful composition, there wouldn't be a picture here at all – we walk past scenes like this all the time, and think nothing of it, yet the photographer has created a great picture by combining careful lens choice with a knowledge of composition

Using people

Composition is really about balance, although that doesn't mean blandness. Things don't have to be the same size, the same colour, the same brightness, the same sharpness or the same importance within a frame to balance a composition – in fact that would be a perfect recipe for a dull photo. Indeed, tiny things can balance beautifully with huge things.

When composing every shot you take, remember that the strongest place to position the subject is while bearing in mind the rule of thirds (see text). I could have placed this fisherman right in the middle of the frame, but the composition would have been far less strong. Note the highlights on the water – without them, the shot may not have worked as well, as they balance the picture

People are the great balancers, because we love looking at people, and our eye shoots to them immediately. By including a tiny face in the corner of a fame, the entire picture is changed and the composition – the leading of the eye around the frame – is altered. Put a girl on that field with the poppy, and see how the poppy takes second place to her.

In fact, using people can help you with that other device for creating good composition – lines.

Lines always lead somewhere, and our eyes obediently follow them wherever they happen to be – imagine a truck in the distance driving towards us along a winding road – our eyes will follow that road until they hit the truck, which is exactly what the photographer wanted us to do.

Lines can be anything – shadows, furrows in a field, the side of a building, road markings – and they can be implied, as when a person's gaze attracts us and we follow the gaze to its conclusion, elsewhere in the frame or perhaps right out of it.

A random selection of lines will merely confuse the viewer – lines are everywhere and it's up to us as photographers to sort them out and make them go somewhere useful.

The rule of thirds

Use your hand to cover the top part of the sea on this picture to make the people on beach sit in the middle of the frame. Once again, the strength of the rule of thirds comes into its own

Any kind of communication needs to have rules: a sentence has to fit in with certain rules if it is to make sense, if the idea you're trying to put across is to be understood by the people you're trying to talk to. It's just the same with the elements within a photograph: they have to be placed in some kind of order if they are to convey their message in the best way.

Of the many rules that can apply to photographic composition, the rule of thirds is one of the most important, and arguably the only one that's worth bothering with.

It works like this. If you look at the most successfully composed photographs, you'll notice something that links them all. Very often, their subject – the most important part of the picture – is placed at a particular point. If you divide the image up into three, horizontally and vertically, you'll notice that the subject often appears on the intersection of those lines. That's the rule of thirds, which has been in use for centuries and still holds sway – just look at the difference if you shoot one portrait of a child with him right in the centre of the picture and another with him slightly above, below or to the side of the centre. It doesn't have to be exactly on the intersection of the lines, but the idea is there.

This rule of thirds isn't really a rule at all: you can ignore it if you like. But if you really look at the pictures you take which you're most happy with, you'll be astonished that they often fit in with this rule. It's a fact!

Exposure modes explained

The strength of a picture like this is the creation of form as the main element within the frame – colour, texture and tone all take a back seat to the simple outline of a boy fishing. With so much dark in the frame, a camera set to automatic or program modes would almost certainly have over-exposed in an attempt to get some detail into the scene. So the photographer used manual and reduced the aperture from the f/5.6 the camera suggested to the f/11 that he knew would reduce everything but the river to black

With the awesome proliferation of ways of reading light, it's easy to become confused by exactly what it is the camera is offering you. Here, then, are the most popular ways of taking a meter reading.

There are only two fundamental ways to read light – **reflected** readings and **incident** readings. Reflected light is the light that bounces off the scene and actually comes through the lens, which is how all camera meters work. Incident light is the light that hits the subject, read by using an invercone (a piece of light-diffusing plastic) over either a camera lens, or more usually, a hand-held light meter.

SUNDAY

Then there are more subtle ways in which a camera reads reflected light. **Spot** metering is becoming more popular, and is a real boon, allowing you to isolate exactly the most important part of a scene, and meter for that precisely. Some cameras have **centre-weighted** metering which takes a general reading biased towards a circle in the centre of the viewfinder. Others opt for **bottom-weighted** metering, which is designed to ensure that the exposure is biased towards the bottom of the frame – where the earth usually is – as opposed to the top where the sky is.

On most modern cameras there is a selection of modes to choose from. **Program** mode measures the light and sets both the shutter speed and the aperture. **High speed program** will err towards the higher shutter speeds for use with long lenses or fast-moving subjects. **Aperture-priority automatic** sets the shutter speed for the aperture you've chosen, while **shutter-speed priority auto** will set the aperture for your shutter speed. Finally, good old **manual** simply measures the light and allows you to choose both shutter speed and aperture to suit your requirements.

EPILOGUE

In such a short book, it's impossible to cover the many aspects of photography, and indeed when I told a friend of mine, a professional landscape photographer, that I was writing this book he said, 'In a week? I've been doing it all my adult life and I still haven't got it right!'

I hope, though, that I've whetted your appetite for further exploration of what is a wonderful, creative and excitingly fulfilling hobby. Nobody pretends that it's easy, and you'll find that the more you learn, the less you seem to know. I've tried, though, to cover the most important aspects of photography here, and I hope I've given you something to work on. For further study, I would thoroughly recommend one of the many hands-on classes run throughout the country by colleges and clubs – there's nothing like learning with other people.

The final words, though, should perhaps go to two of my favourite photographers, war journalist-turned-landscape photographer Don McCullin, and the great portraitist Arnold Newman . . .

'Look at the work of the great photographers; Steichen, Stieglitz, Brandt. Looking at their work will teach you more about photography than most things.'

Don McCullin

'Just go out there and work like hell. If you're lucky, God's given you something to work at. But you've got to work at it all your life. There really is no magic formula.'

Arnold Newman

GLOSSARY

aberration the inherent optical imperfection of every lens, usually minimised in the construction process, but never entirely eliminated. Cheaper lenses have greater aberration problems.

air release long cable release with a bulb at one end which, when squeezed, activates the shutter.

aperture the opening of the lens, which allows light to enter the camera, measured by the f/number. Affects both exposure and depth-of-field.

ASA stands for American Standards Association, which in 1943 laid down a general measurement for film speeds. Now superseded by International Standards Organisation, ISO.

autofocus cameras those with in-built motors which focus the lens automatically. Since their introduction in 1985, these cameras have become astonishingly accurate and fast.

cable release · a mechanical device for tripping the shutter without the photographer touching it. Vital for use with a tripod when using shutter speeds of less than about 1/30sec.

camera format the size of the film a camera takes – the most common running from 35mm to 10 × 8in.

camera shake the movement of the camera while the shutter is open, causing blurring. Can occur at speeds as fast as 1/125sec, and usually does at speeds less than 1/30sec.

colour temperature light varies from very blue (daylight at noon) to almost orange (a household bulb), and the colour temperature, measured in Kelvins, is the empirical measurement of this colour.

daylight-balanced film is balanced to produce natural results at a colour temperature of 5600K.

depth-of-field the amount of the photograph that is acceptably sharp, affected by aperture, distance between camera and subject, and focal length of the lens.

differential focusing the use of a wide aperture or long lens to accentuate the different planes of focus – for instance to throw a distracting background out of focus.

DX-coding saves the need to set the ISO rating on the camera, since the camera reads the film's speed from the barcode located on the film canister. DX doesn't actually stand for anything.

exposure meter a guide – and only that – to the exposure you should use, either built into the camera or hand-held.

exposure the amount of light you allow to reach the film by choosing the right combination of aperture size and shutter speed.

extension tube a metal ring which can be fitted between the camera and lens to allow extra close focusing.

f/number is the number given to the aperture settings on the lens. A typical lens will run from f/3.5 to about f/22, the smaller number denoting a wider aperture.

GLOSSARY

film speed the film's sensitivity to light, measured by ISO.
filters glass, plastic or gelatin, these affect the colour of light, create
 special effects or simply produce on film what you see with your eyes.
 Every photographer should have some.
fish-eye lens so called because they look like a fish's eye, these ultra-
 wide-angle optics usually create circular images.
fixed-focus cameras are at the cheaper end of the compact spectrum,
 and work by using maximum depth-of-field to ensure sharp results.
focal length is the optical term for a lens' magnification level, measured
 in millimetres. A typical wide-angle is a 28mm, a typical telephoto is
 200mm, and the standard lens, which reproduces the scene much as
 our eyes saw it, is a 50mm on a 35mm camera.

grain the structure of film, increasing in visibility with the speed of the
 film.

hyperfocal distance the distance between the camera and the sharpest
 point, when the lens is focused on infinity.

incidental light reading a meter reading of the light falling *onto* the
 subject, rather than reflected from it.

landscape format a photograph that is wider than it is high.
large-format cameras take 5 × 4 inch and 10 × 8 inch film sizes.
latitude the range of exposures that will be acceptable for a given film/
 subject combination. Negative film has wider latitude than
 transparency material.

macro the term used when the image size is 1:1 or larger than the
 subject size.
medium format cameras are cameras whose film sizes runs from 6 ×
 4.5cm to 6 × 7cm.
meter readings are the readings worked out by your camera or a
 hand-held light meter that suggest the correct shutter speed/aperture
 combination to expose the film correctly.
mirror lens a telephoto lens that uses mirrors rather than glass in its
 construction. Usually cheaper and lighter than ordinary teles, they are
 also usually restricted to one aperture setting.

neutral density filter a filter used to reduce the amount of light reaching
 the film without affecting tone or colour.

parallax error the difference between what the taking lens sees and
 what the viewing lens sees in non SLR cameras. Especially
 problematic when shooting close-ups.
polarising filter filters out polarised light, reducing reflections,
 deepening colours and adding contrast.
portrait format is a picture which is taller than it is wide.

GLOSSARY

portrait lens usually a lens of about 80mm with a 35mm lens – ideal for portraits.

red-eye the reflection of light off the retina of the eye, caused by the flash being too close to the lens axis. Avoided by taking the flash away to one side of the camera or asking the sitter to look away slightly.

shutter the mechanical or electronic device which opens for a given period of time to allow light to reach the film.

shutter speed the length of time for which the shutter opens, running on most cameras from about a second to 1/1000sec.

SLR single lens reflex cameras, which enable the photographer to see exactly what the film will be exposed to by using mirrors.

soft-focus a filter or lens used to soften the harshness of a portrait, landscape or any suitable subject. Not the same as out of focus.

standard lens the lens with the nearest approximation to the human eye. For 35mm cameras it is 50mm, for medium-format cameras, it is 80mm.

stops are the short-hand photographers use for changes in exposure, each stop denoting twice as much, or half as much, light entering the camera. To increase the exposure by a stop means doubling the amount of light that reaches the film – one click of the aperture ring (from f/8 to f/5.6, say) or one click of the shutter speed dial (from 1/125sec to 1/60sec) is an increase in exposure of one stop.

teleconverter an optical arrangement that fits between the lens and the body to increase the lens's focal length.

telephoto lens any lens that is physically shorter than its focal length (like a 1000mm), achieved by using composite elements within the lens itself.

transparency film film that creates a positive image – in other words, it looks as the scene did – on exposure, also called slide film.

warm-up filter a straw or yellow-coloured filter used for adding healthy tan to portraits and rosy glow to landscapes. Vital bits of kit.

x-rays can fog film. Speeds over ISO800 should not be exposed to X-ray, and multiple exposure causes a cumulative effect.

zoom a lens with a variable focal length.

South Essex College

Further & Higher Education, Southend Campus
Luker Road Southend-on-Sea Essex SS1 1ND
Tel: 01702 220400 Fax: 01702 432320
Minicom: 01702 220642